COLUMBUS TODAY

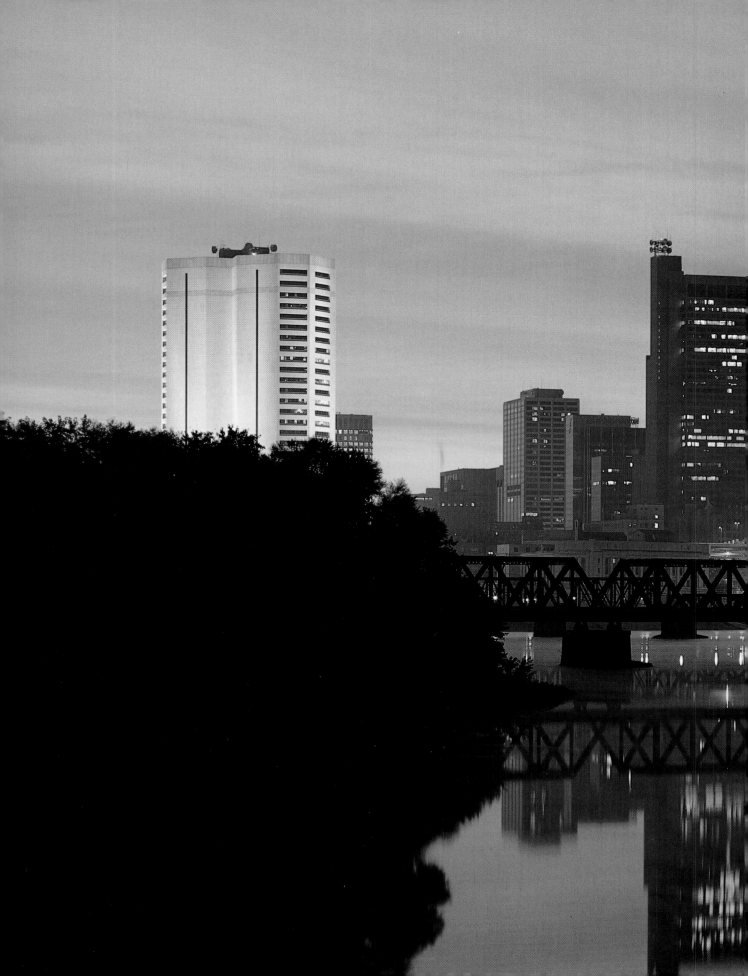

COLUMBUS TODAY
A Portrait in Color

Photographed by Ed Kreminski

A&M

Altwerger and Mandel Publishing Company, West Bloomfield, Michigan

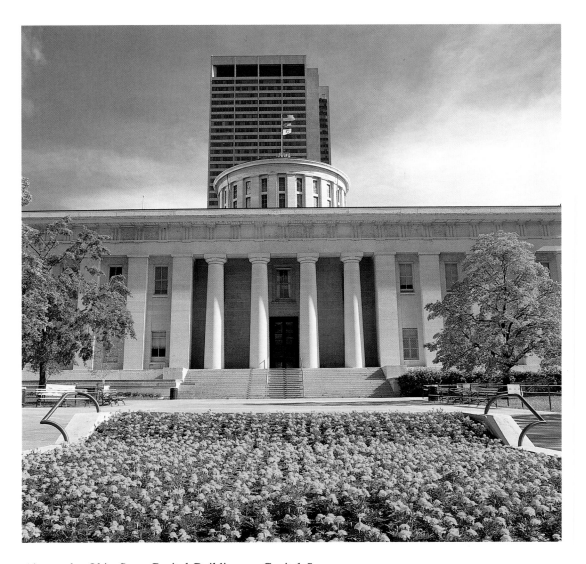

Above, the Ohio State Capitol Building on Capital Square.

Preceding pages, sunrise on Columbus and the Scioto River.

ISBN 1-878005-07-3

Designed by Mary Primeau

A&M Publishing Company
6346 Orchard Lake Road, Suite 201
West Bloomfield, Michigan 48033
Printed in Singapore through Palace Press

FOREWORD

Columbus is within 600 miles of two-thirds of the nation's population. It is Ohio's capital and thus the hub of all the state's government activity. It boasts a fine quality of life, filled with the fine arts, a wonderful zoo, an exciting and growing downtown area, year-round sports activities for both the spectator and active participant, and a great variety of civic and community events. Greater Columbus also encompasses pleasant suburbs accentuated by a substantial and beautiful public park system.

The best attribute of Columbus is its people. They are friendly, professional, and upbeat about their dynamic city. Look for outdoor concerts in the summer, the State Fair, walks and shopping tours of the unique and beautifully restored German Village area, and the hustle and talent of the Ohio State University campus, especially during a fall football game.

All this and more; we, the publishers, hope the photography of Ed Kreminski will help you know, remember, and discover Columbus.

—*The Publishers*

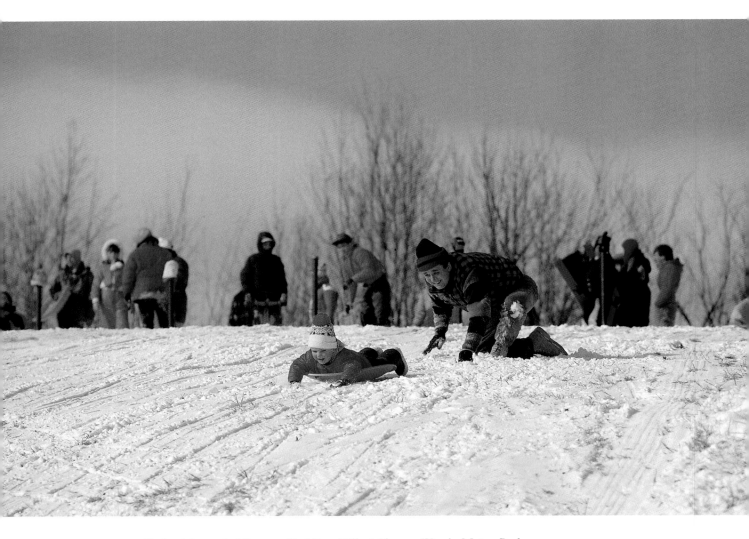

Park visitors sledding on Sledding Hill at Sharon Woods Metro Park.

Summertime volleyball on the beach at Alum Creek State Park.

Following pages, "The Best Damn Band in the Land"—the Ohio State Marching Band.

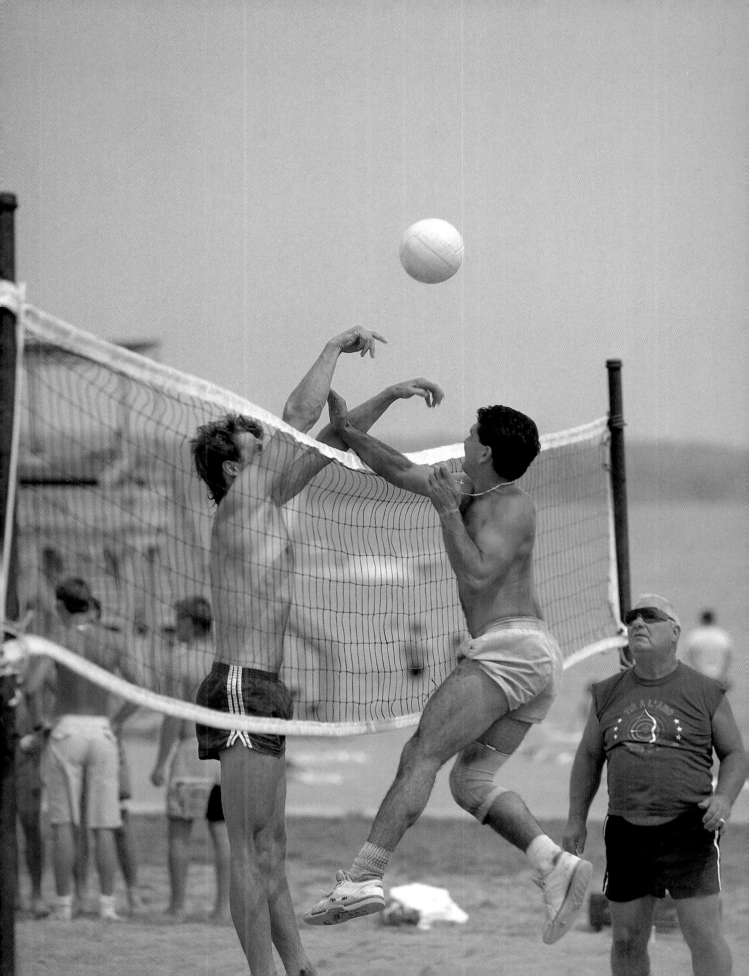

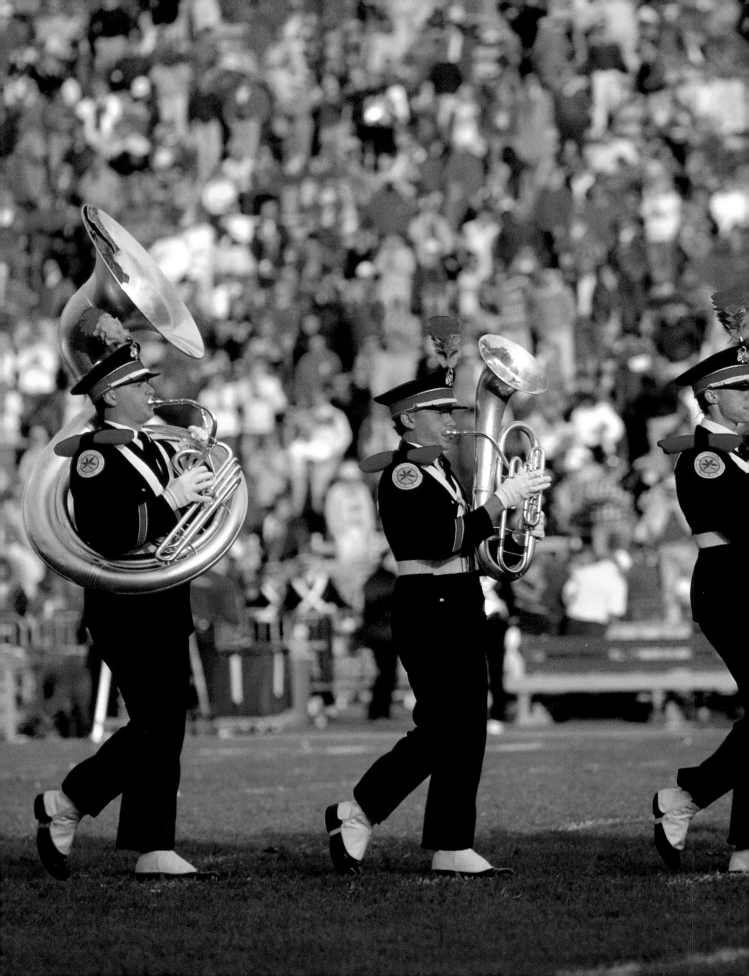

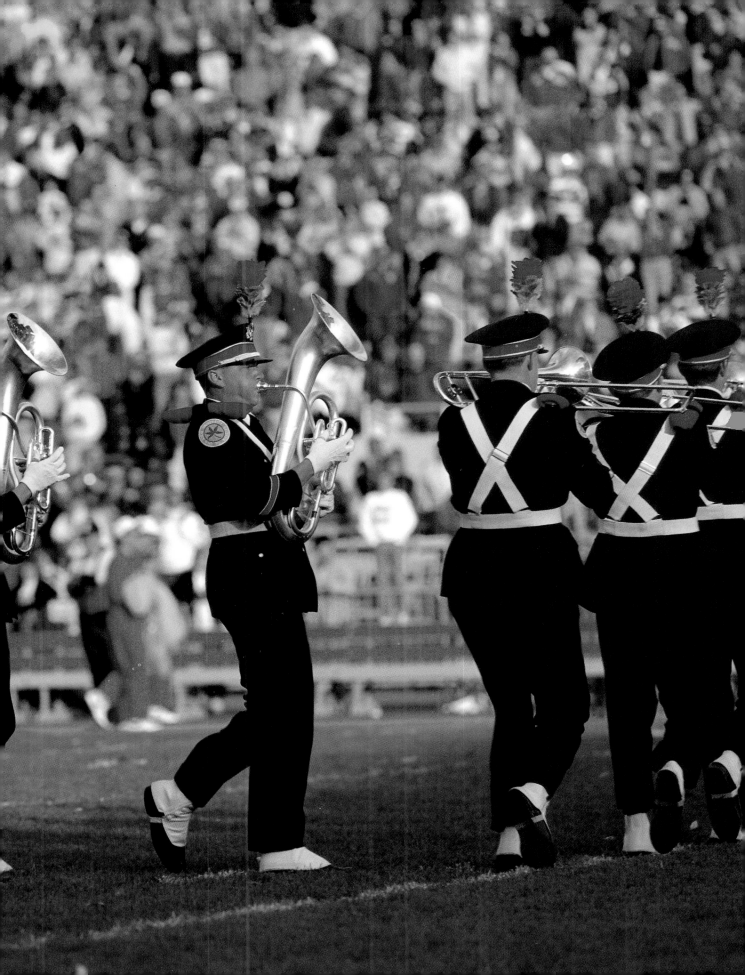

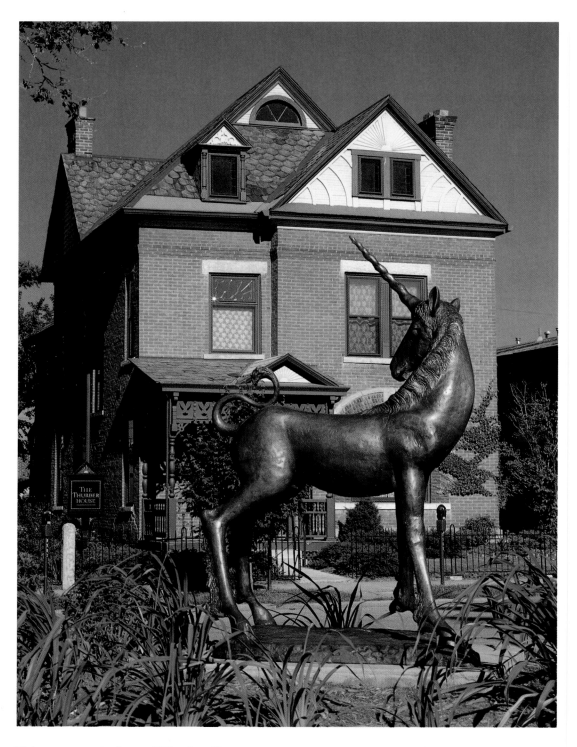

Unicorn statue in front of Thurber House.

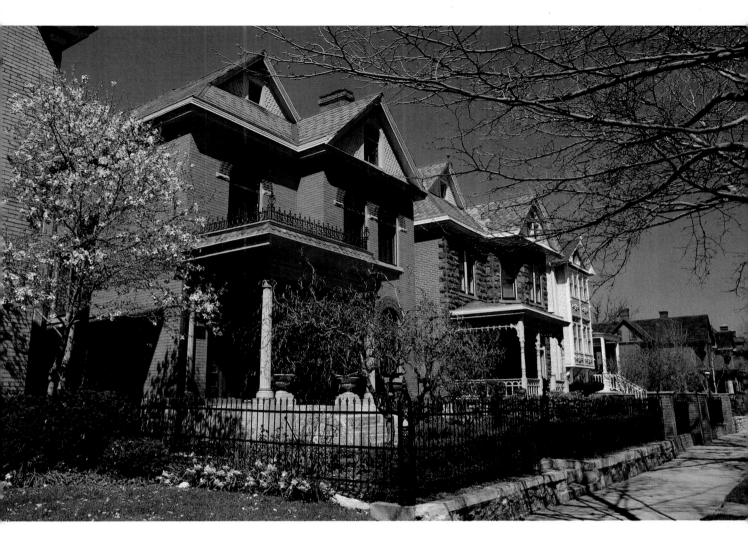

Renovated houses in Victorian Village.

Following pages, the Columbus skyline reflected in the Scioto River at twilight.

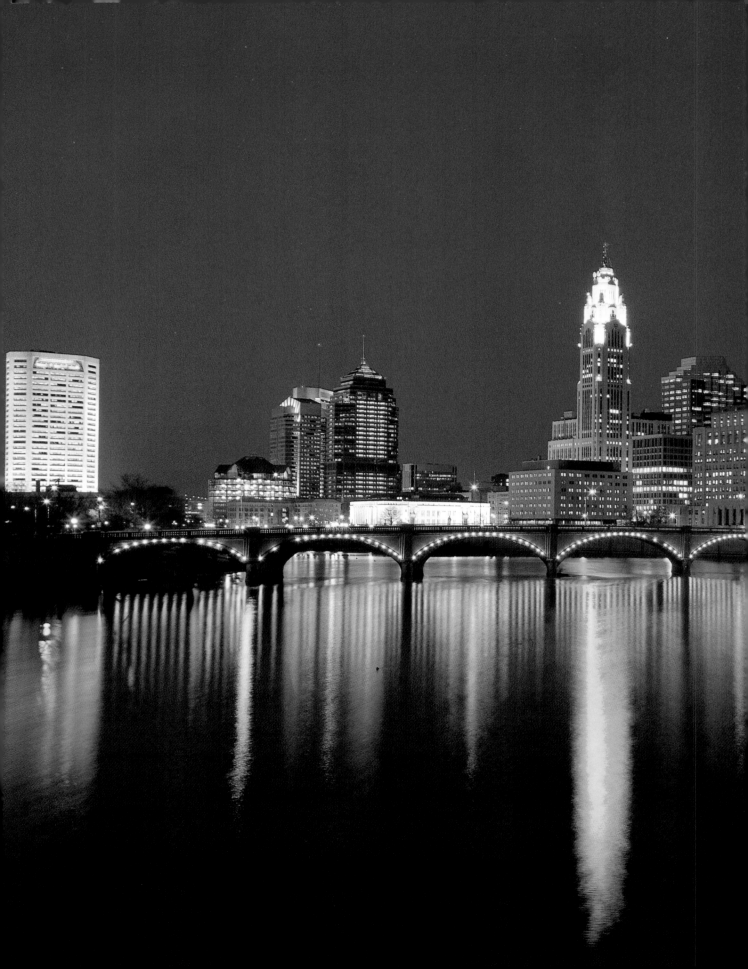

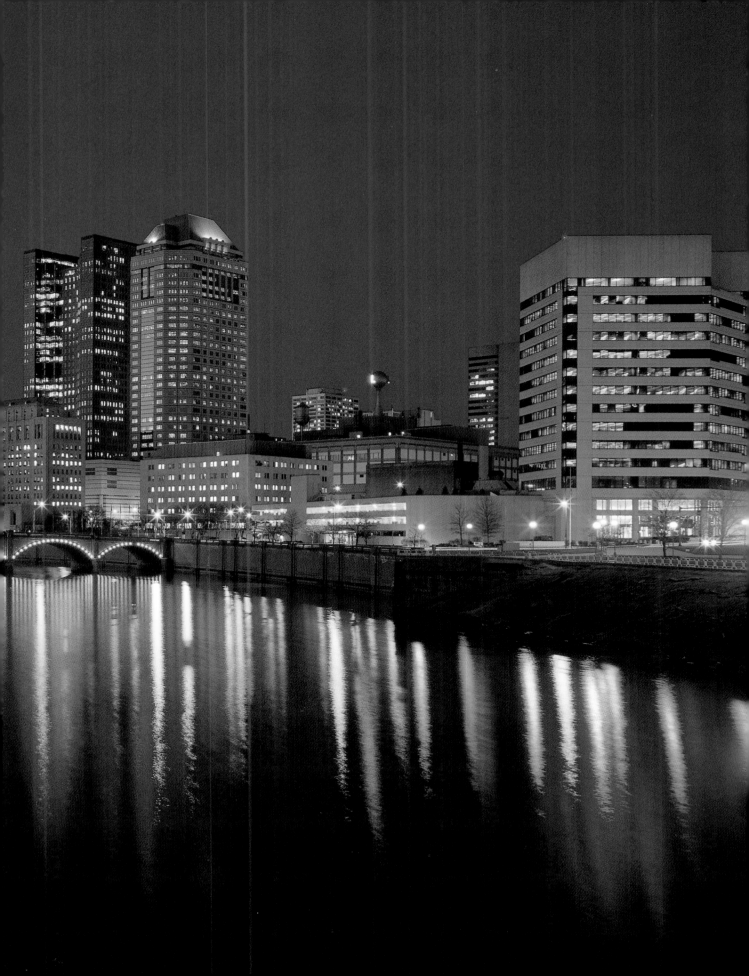

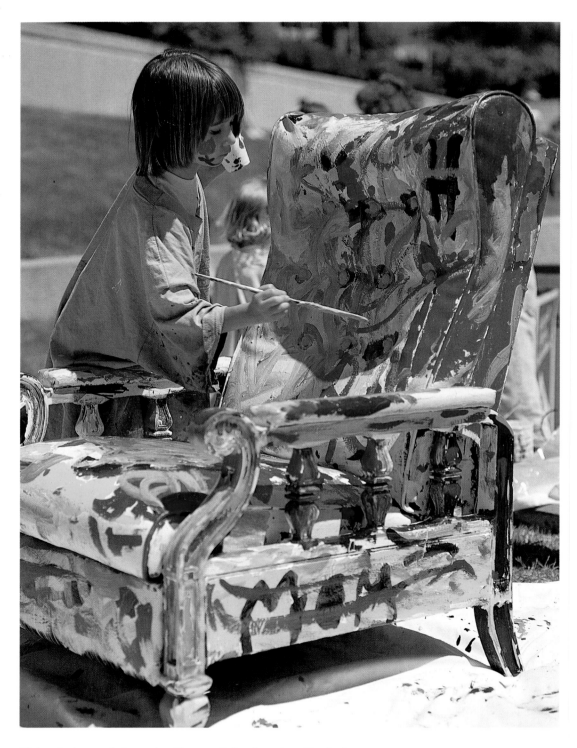

Girl painting a chair at the Greater Columbus Arts Festival.

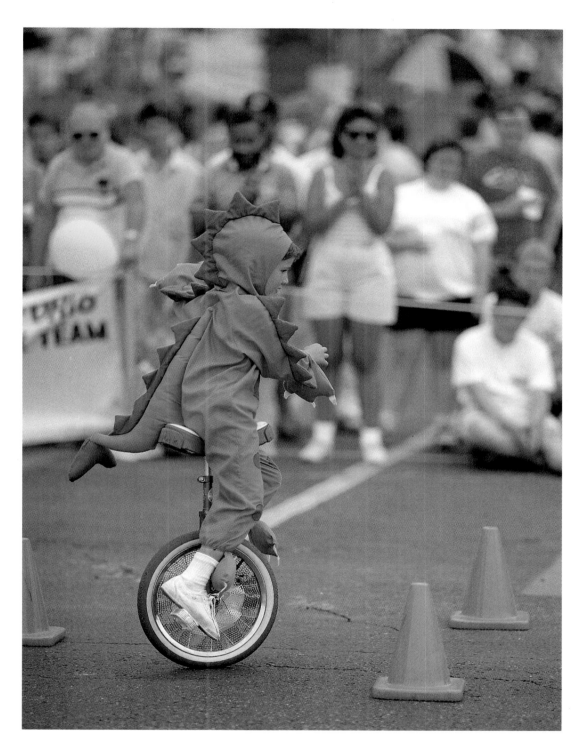

Child unicyclist at the Scioto Superfest.

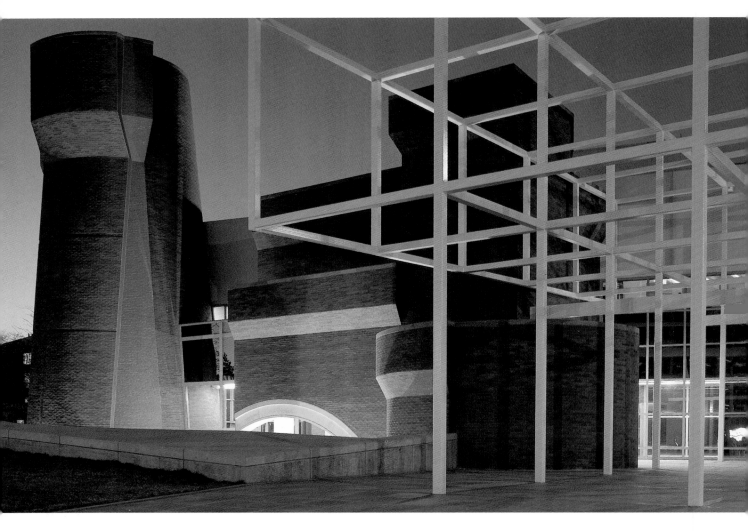

The Wexner Center for the Visual and Performing Arts is one example of postmodern architecture in Columbus.

The Vern Riffe Center for Government and the Arts (right) contains the Capitol Theatre.

Following pages, National Street Rod Association Rally, held every three years in Columbus.

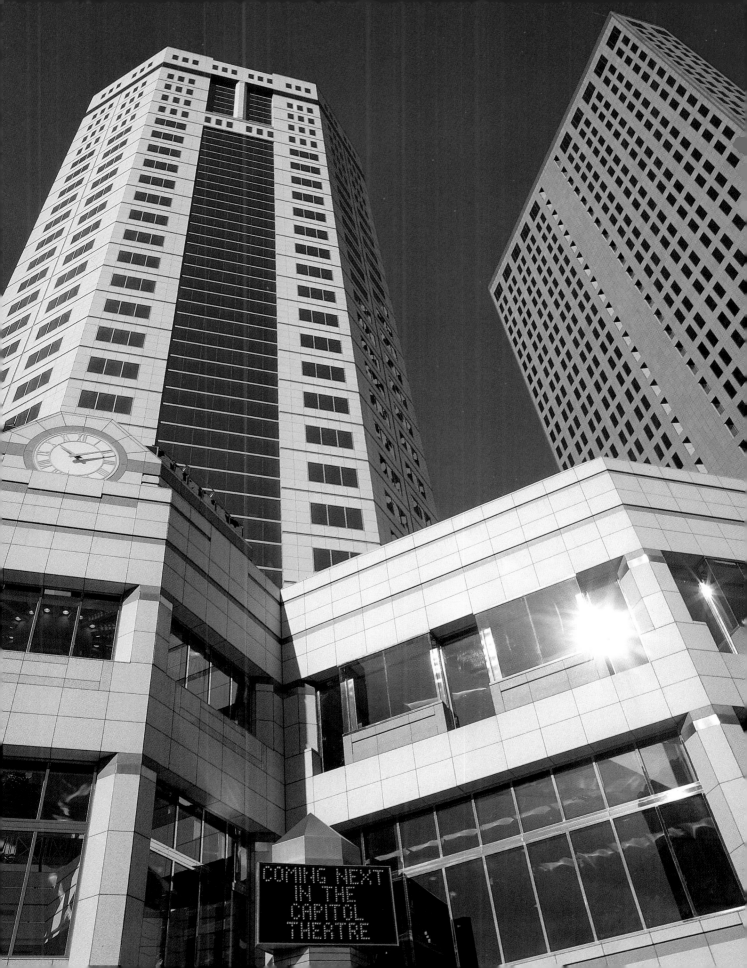

COMING NEXT
IN THE
CAPITOL
THEATRE

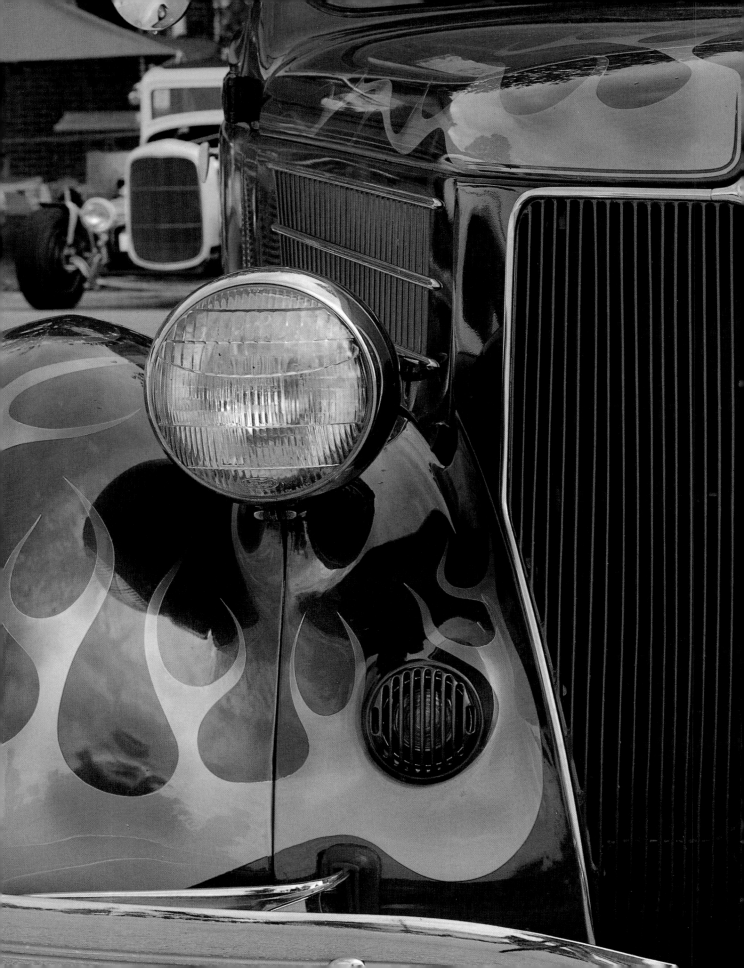

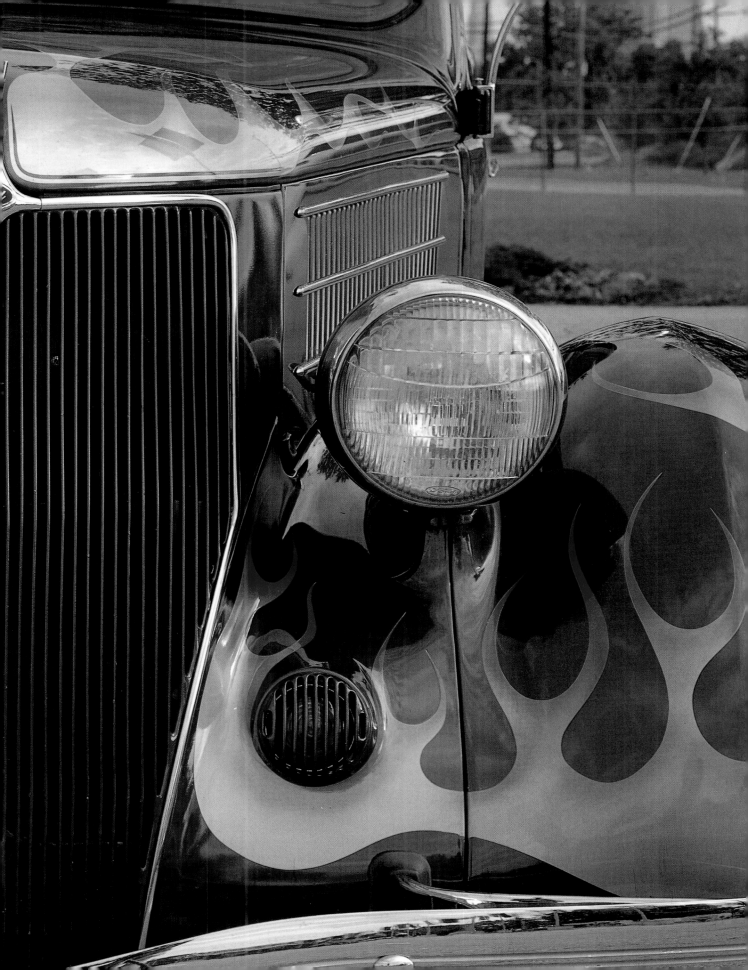

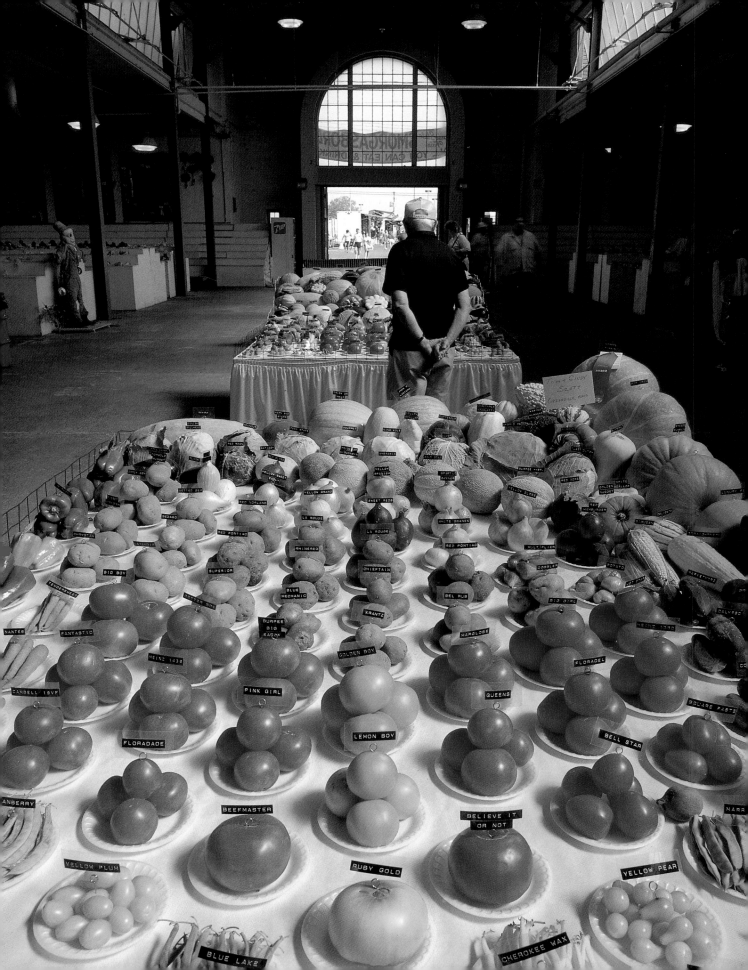

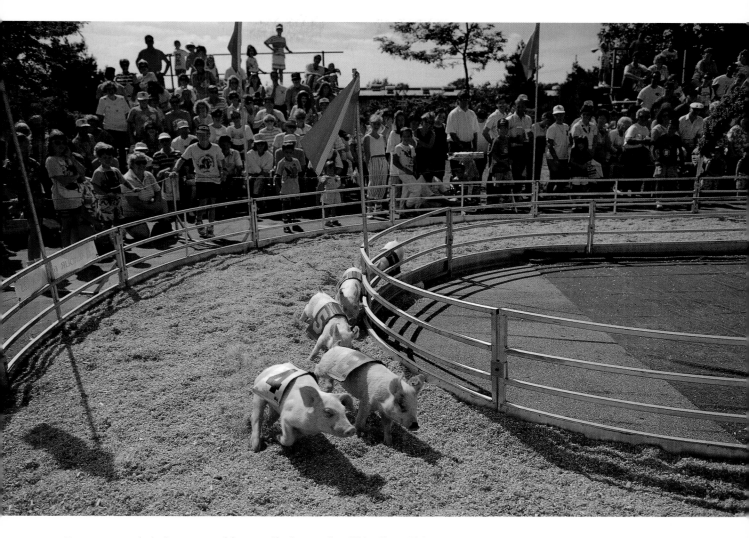

Farmers put their best vegetables on display at the Ohio State Fair.

Pig races at the Ohio State Fair.

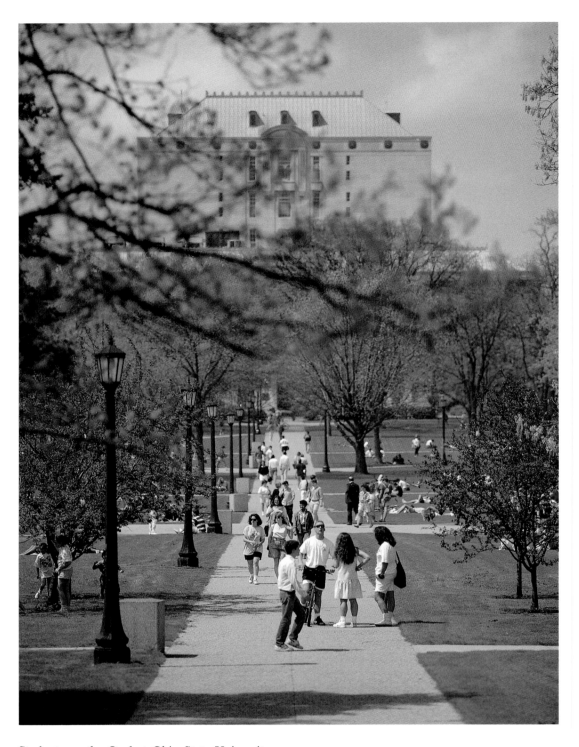

Students on the Oval at Ohio State University.

Orton Hall Tower (right) at OSU campus.

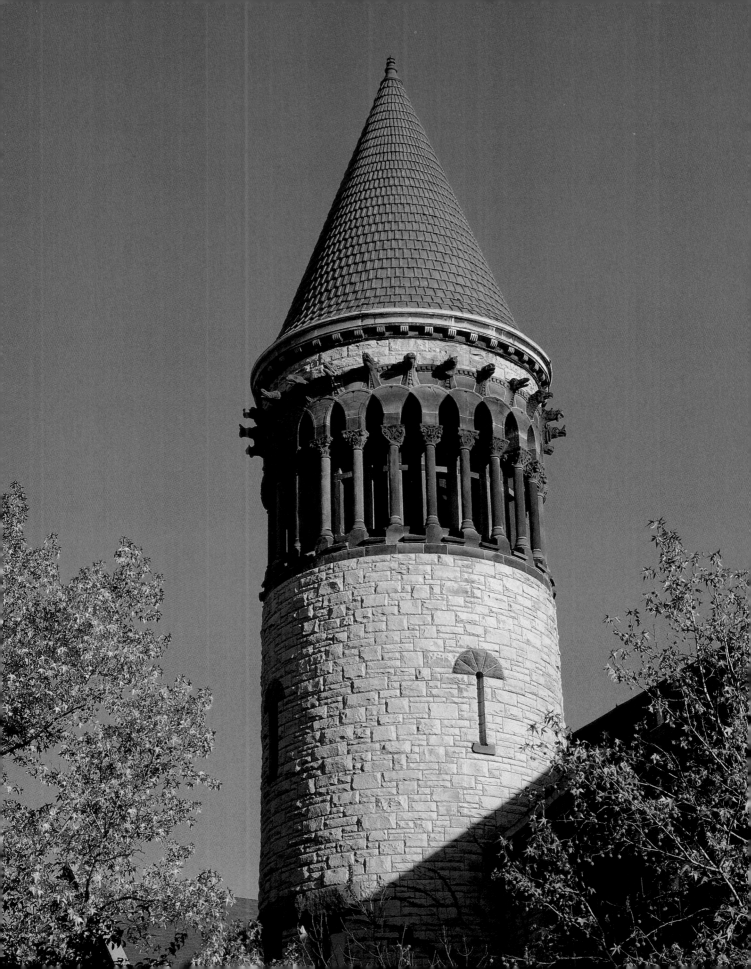

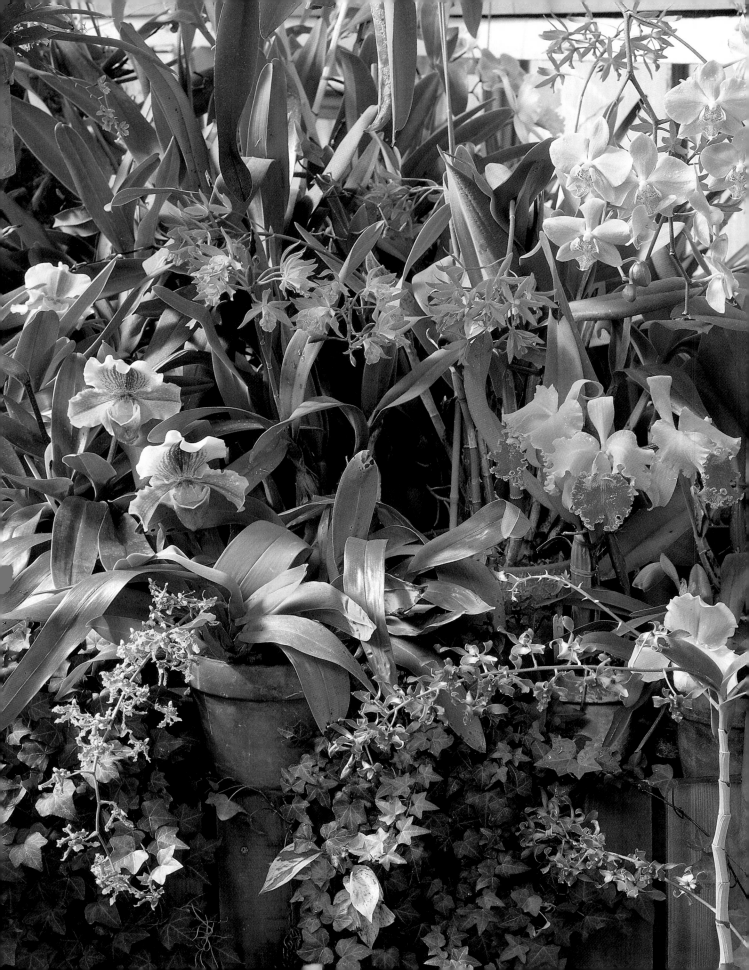

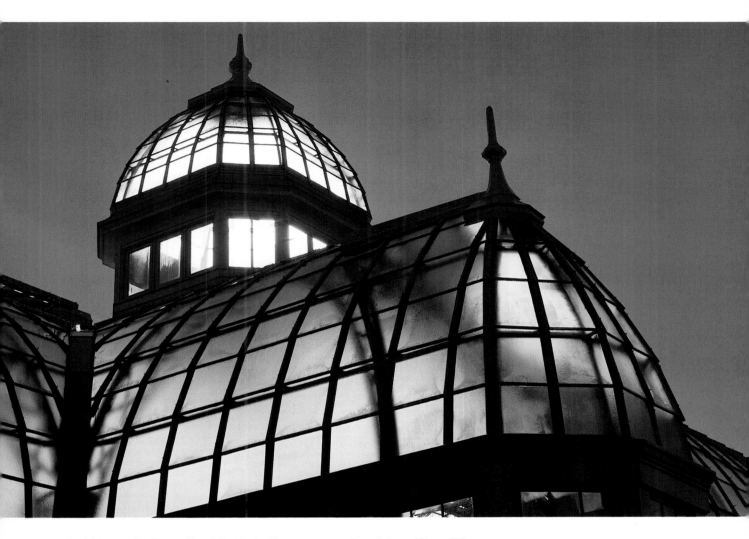

Orchids on display at Franklin Park Conservatory, site of Ameriflora '92.

Franklin Park Conservatory.

Following pages, crowd cheering at OSU homecoming football game.

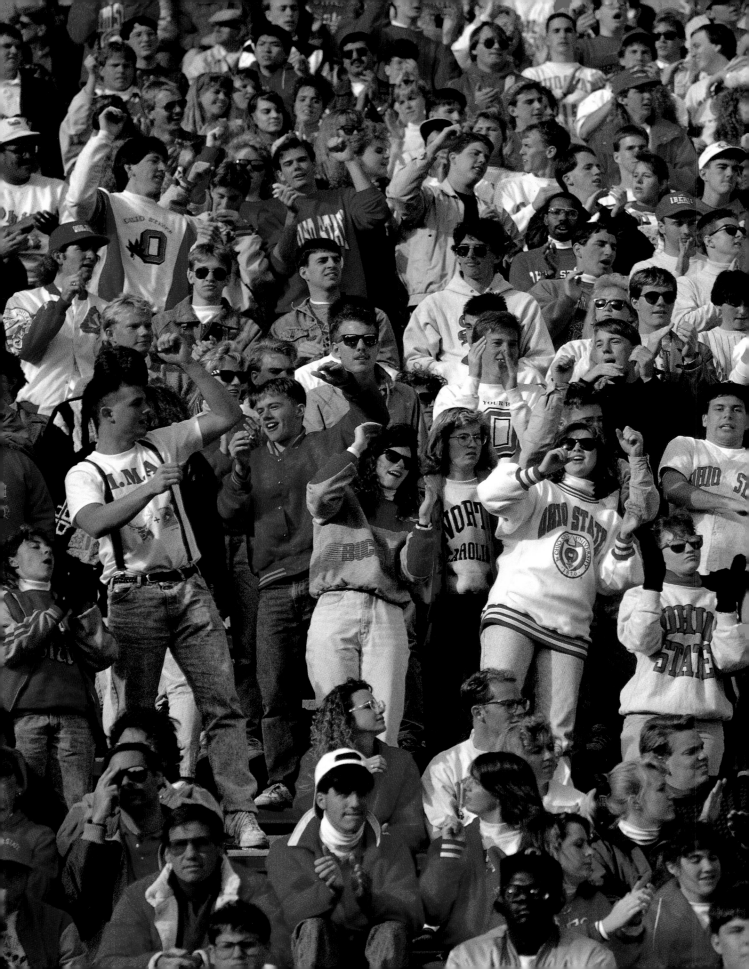

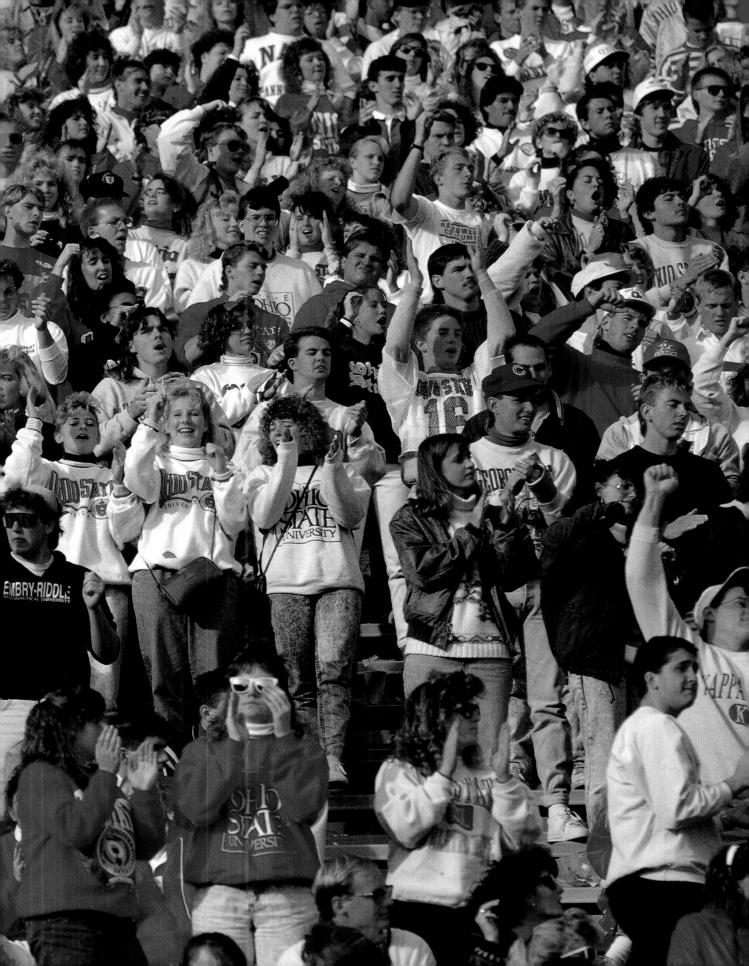

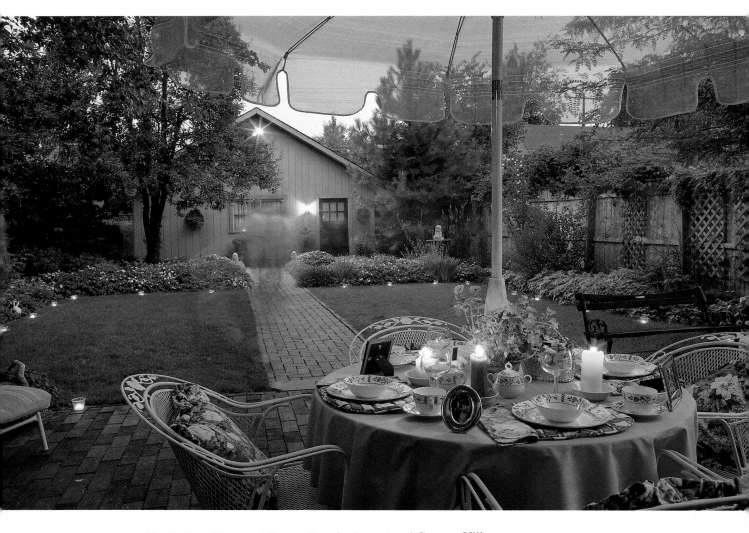

Candlelight *Haus und Garten Tour* in the restored German Village area.

Fireworks enliven the Columbus Symphony Orchestra's summertime picnic with the Pops concert series.

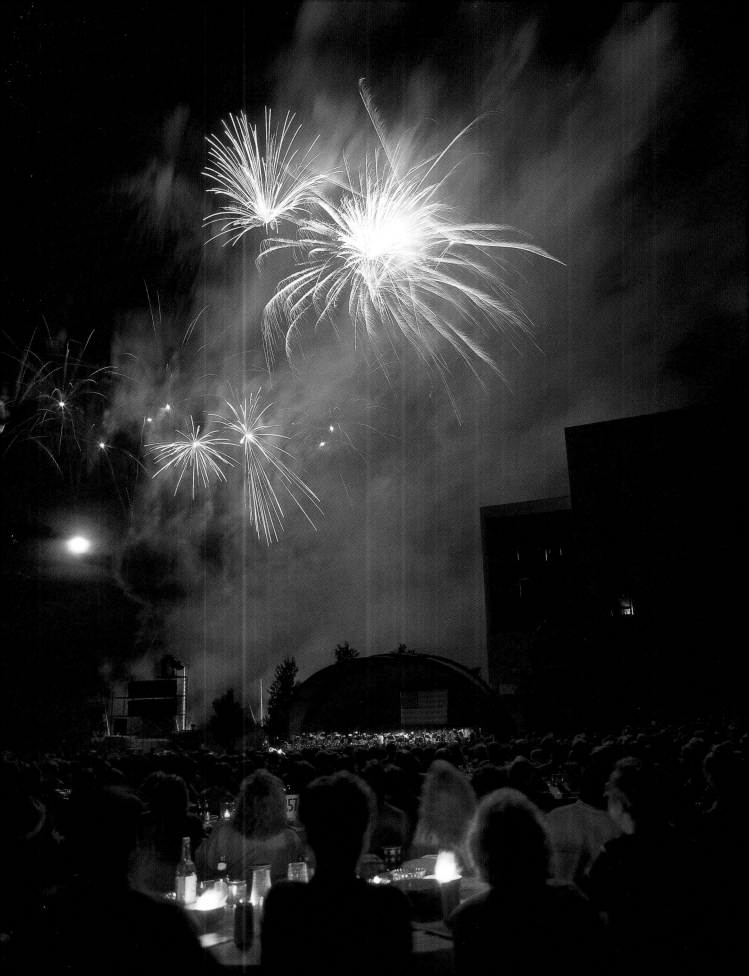

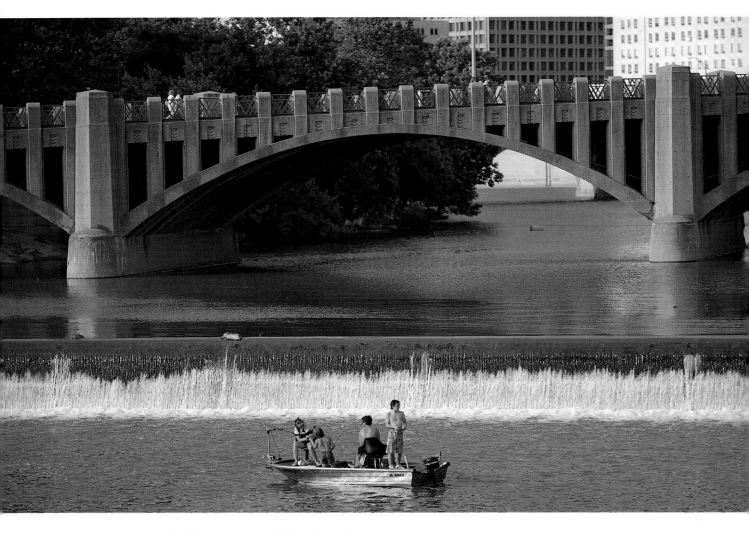

People fishing near the Main Street bridge.

Contestants in the Bud Light Triathalon run toward the finish line.

Bicyclists return from the Tour of the Scioto River valley.

Following pages, the neon sculpture in front of the Ohio Theatre is the logo for the Greater Columbus Art Festival.

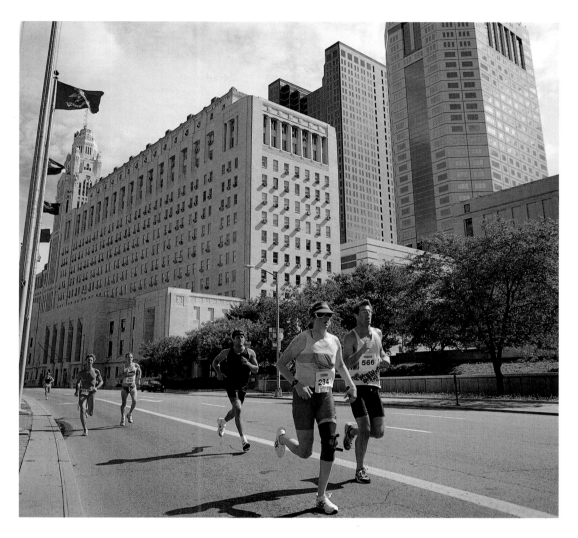

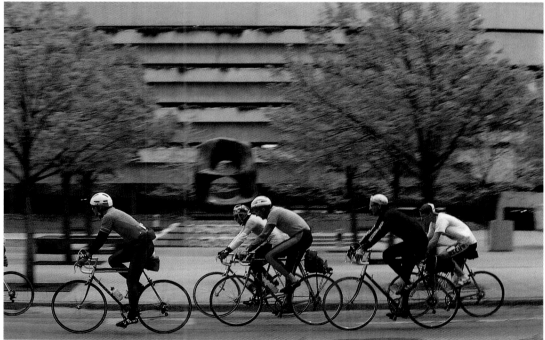

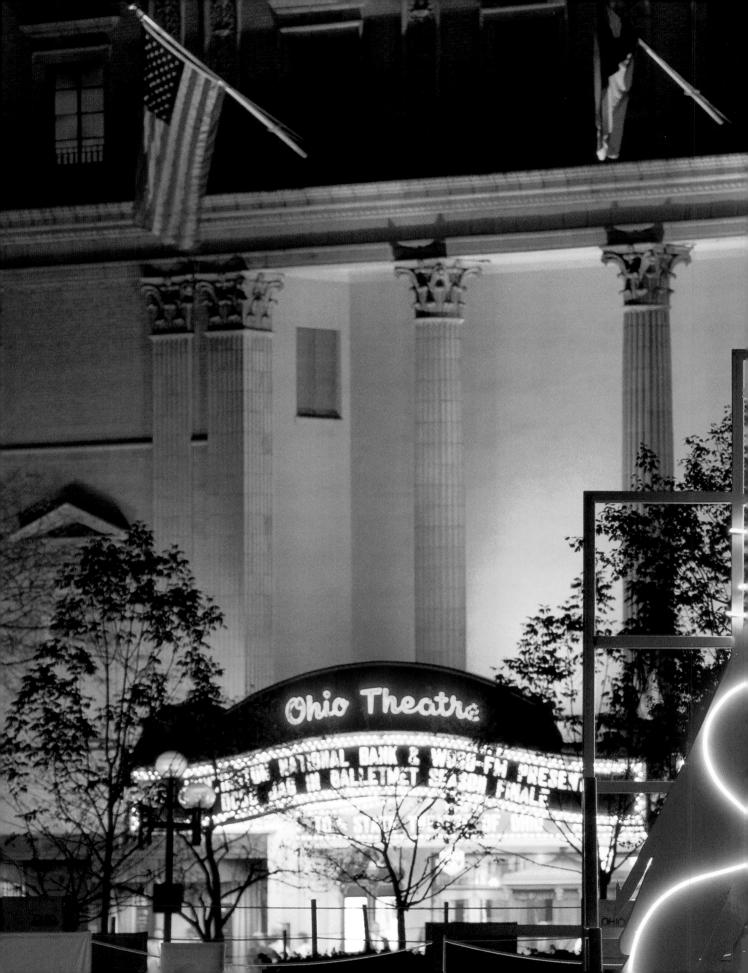

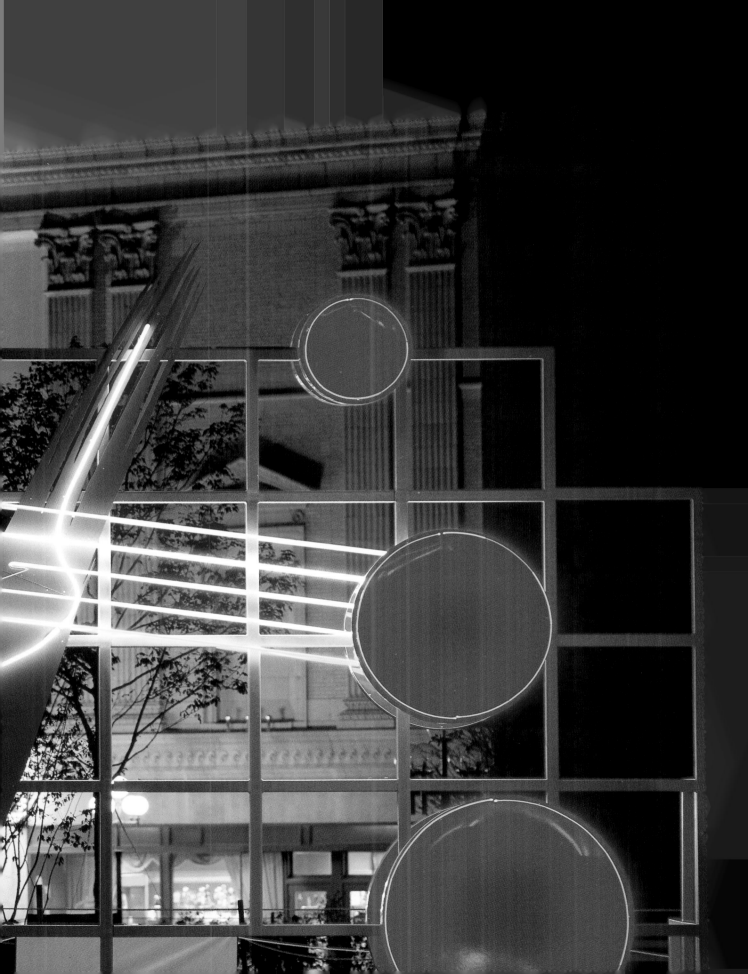

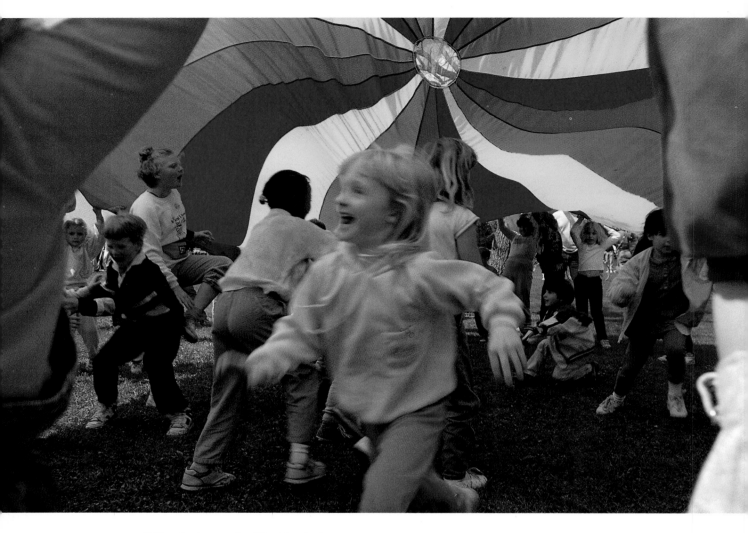

Kids playing at the Kite Festival.

Kids riding a roller coaster at the Ohio State Fair.

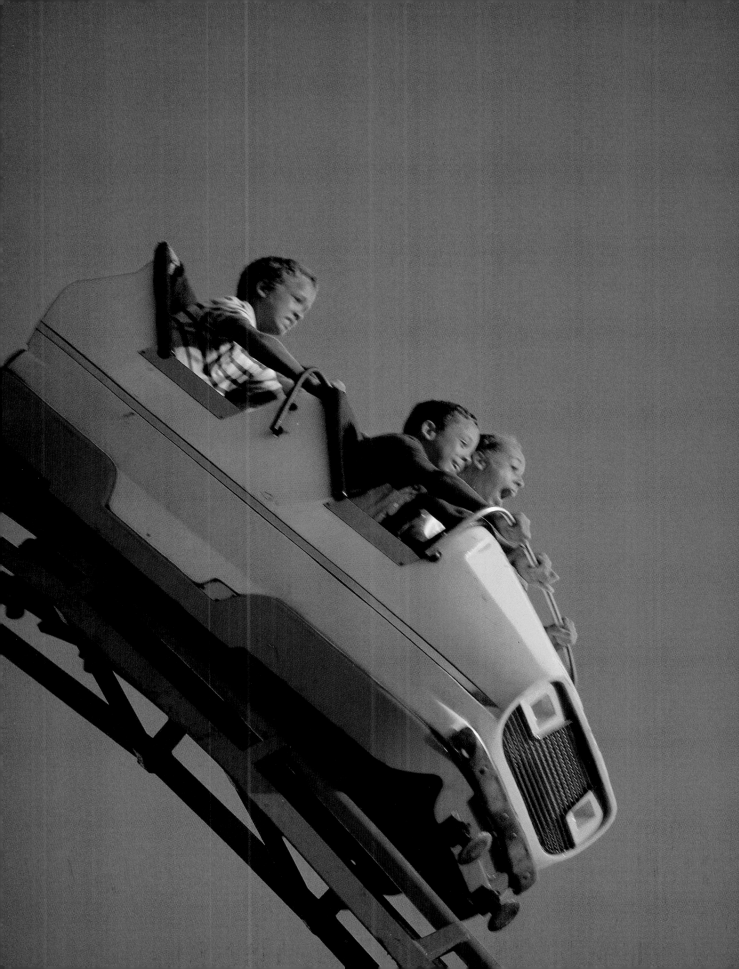

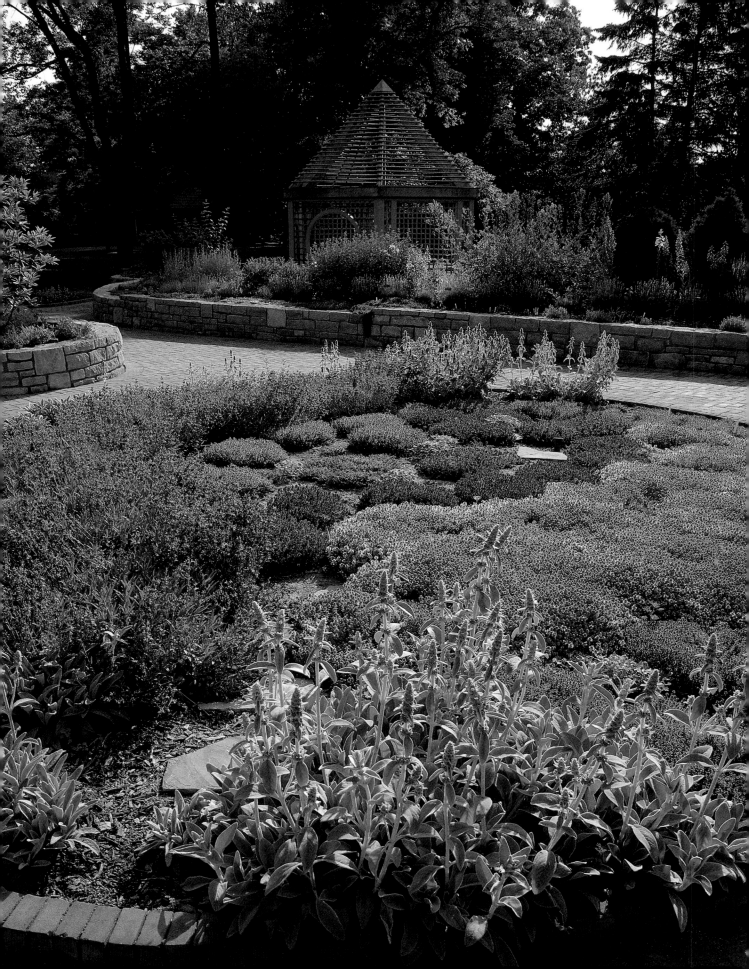

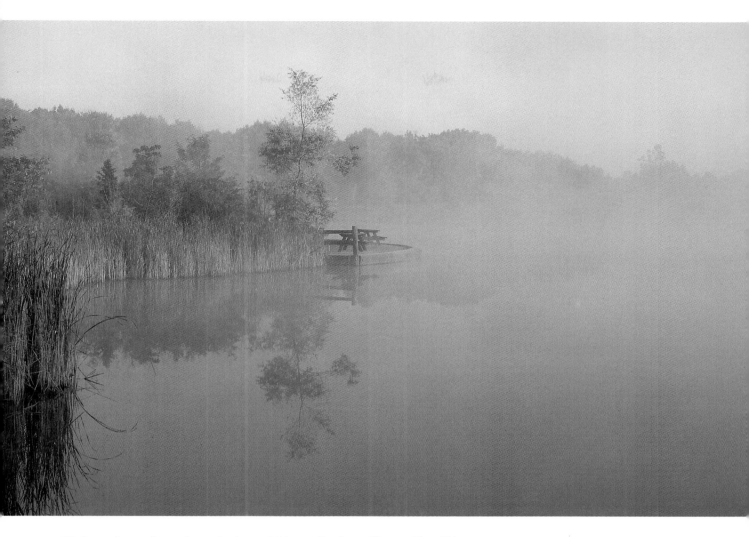

Herb garden and gazebo at Inniswood Metro Gardens, Westerville, Ohio.

Early morning fog on Shrock Lake at Sharon Woods Metro Park.

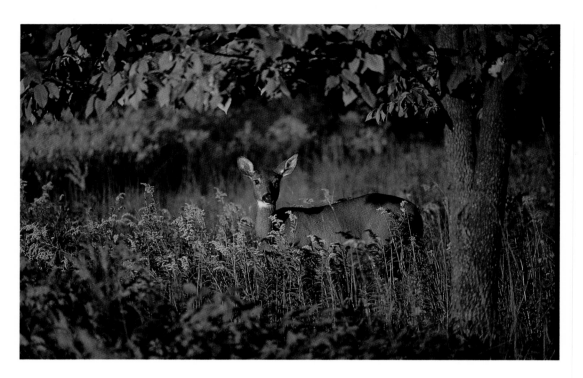

White tailed deer at Sharon Woods Metro Park.

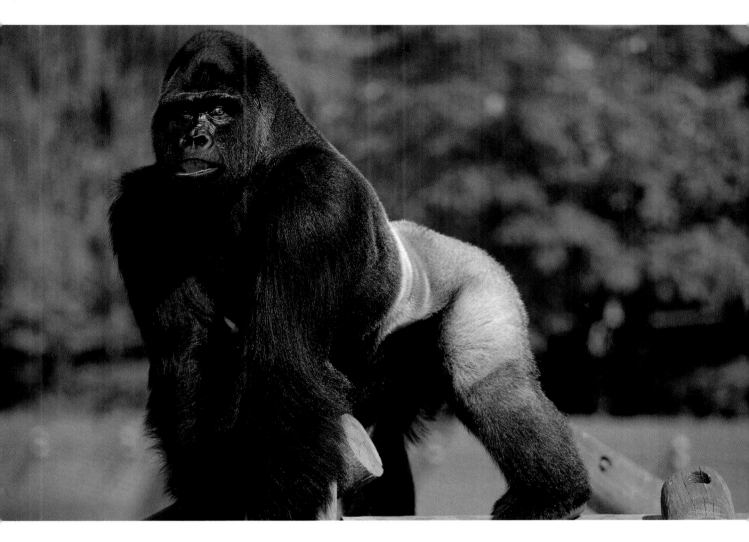

Gorilla at the Columbus Zoo.

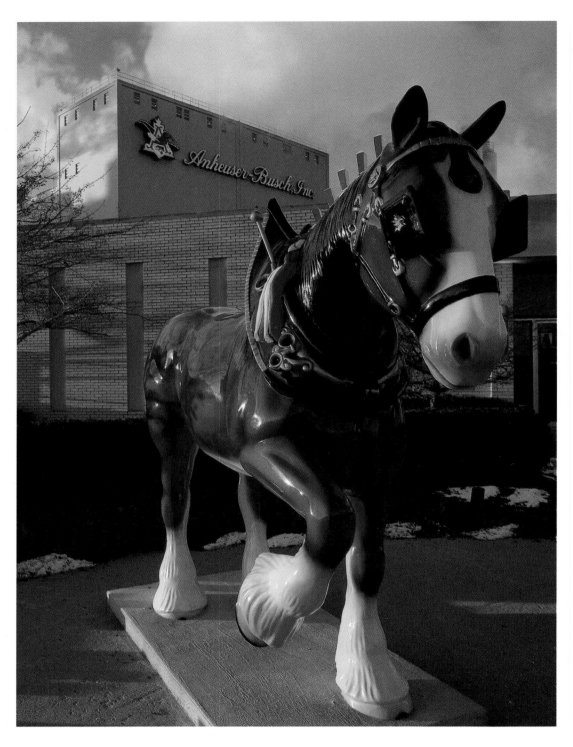

Clydesdale statue at Anheuser-Busch Brewery Visitor's Center.

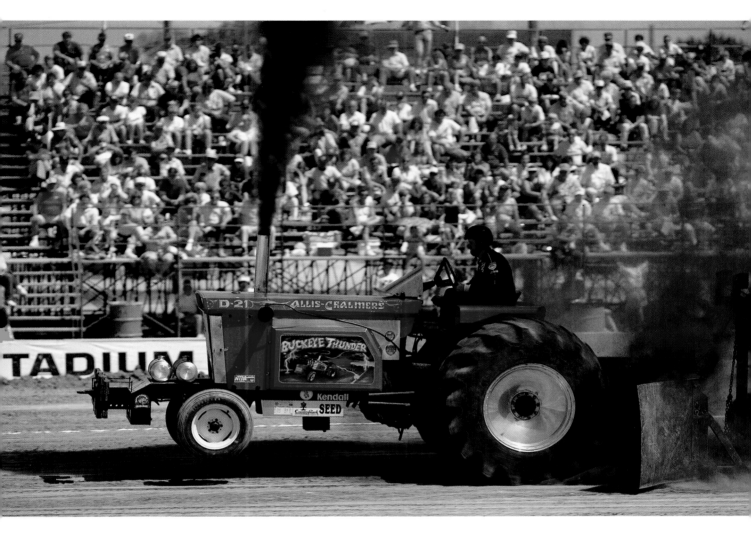

Tractor-pull contest at the Ohio State Fair.

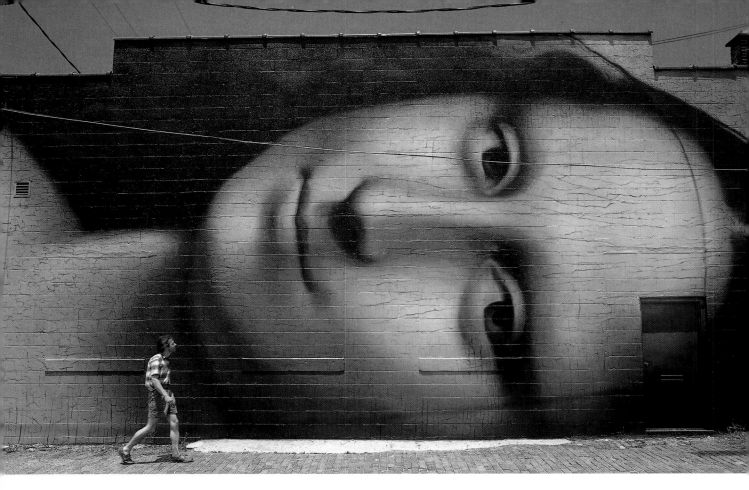

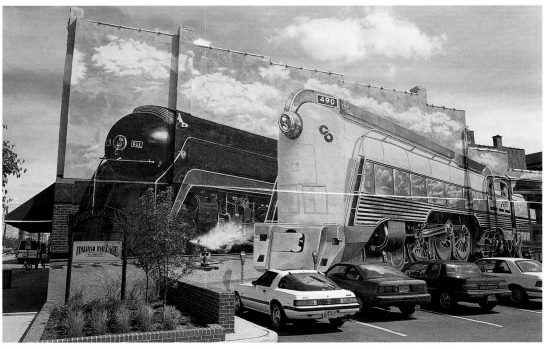

Mona Lisa painted on the side of the Reality Theater Building in the Short North area.

Locomotive mural, near the Short North area in Italian Village.

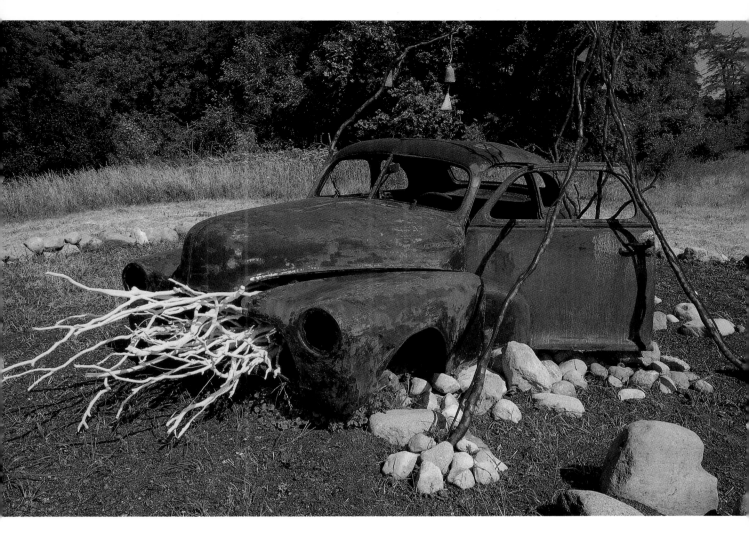

Outdoor sculpture at the Sculpture Garden at Heritage Village.

Following pages, members of the Hoover Yacht Club sailing on the Hoover Reservoir.

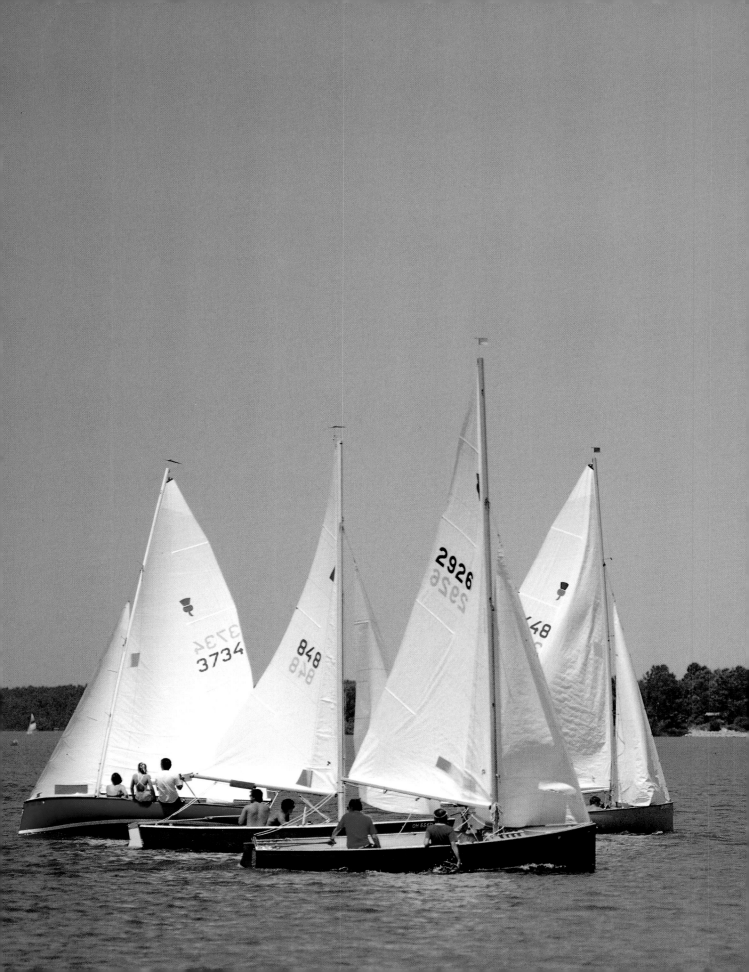

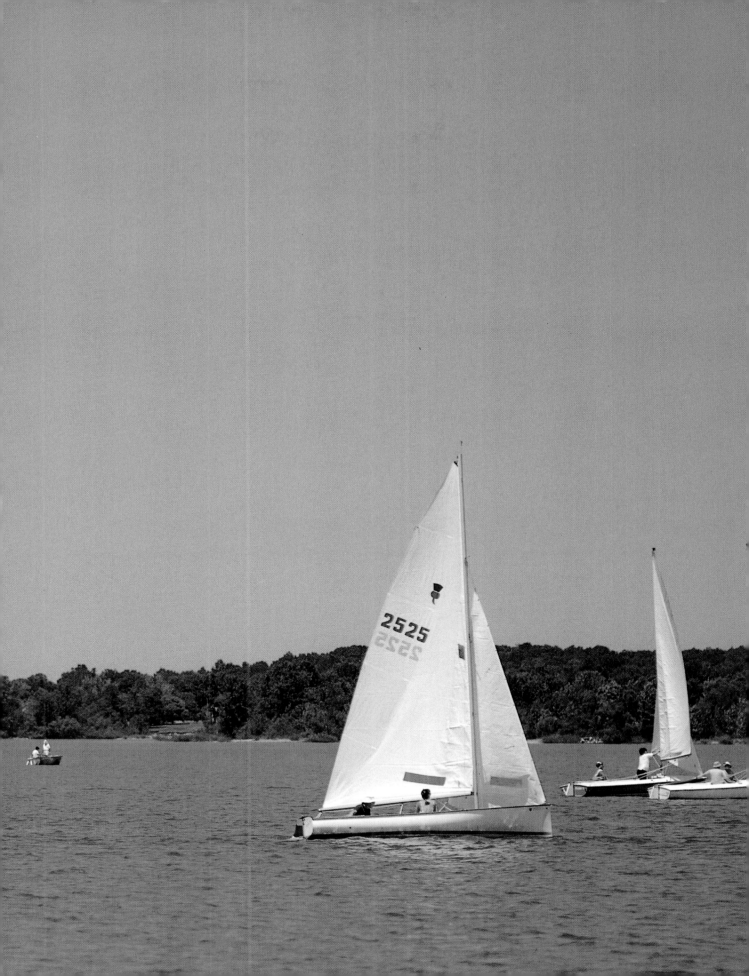

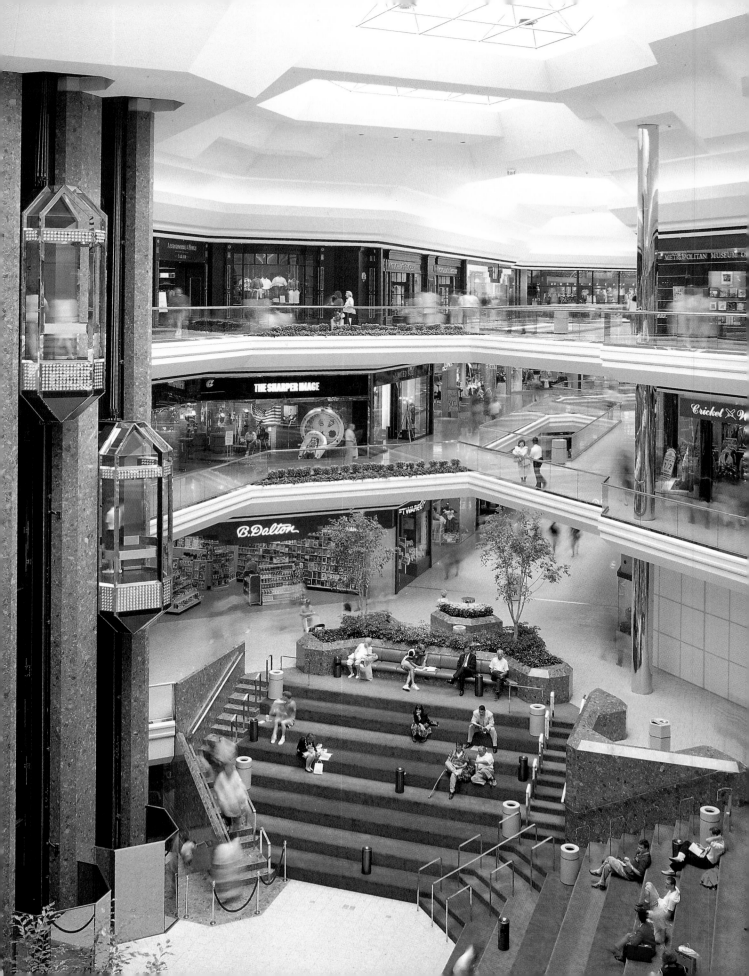

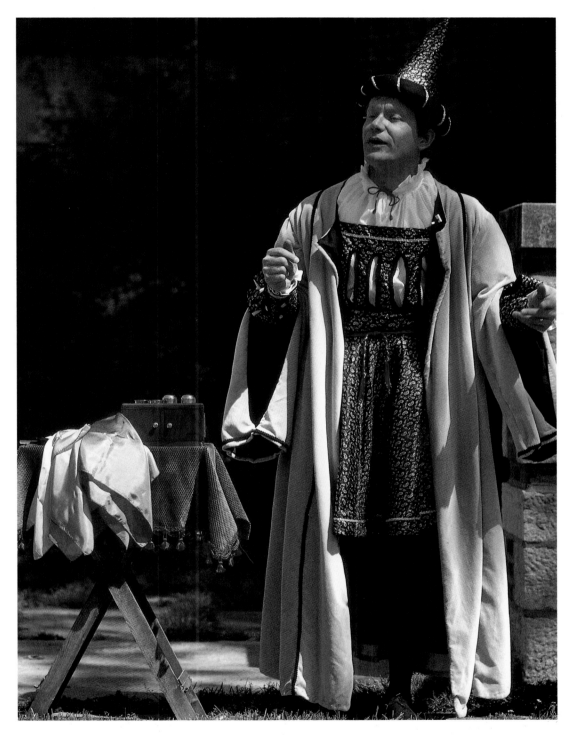

City Center Mall (left) brings luxury shopping to downtown Columbus.

Above, magician at OSU Medieval and Renaissance Festival.

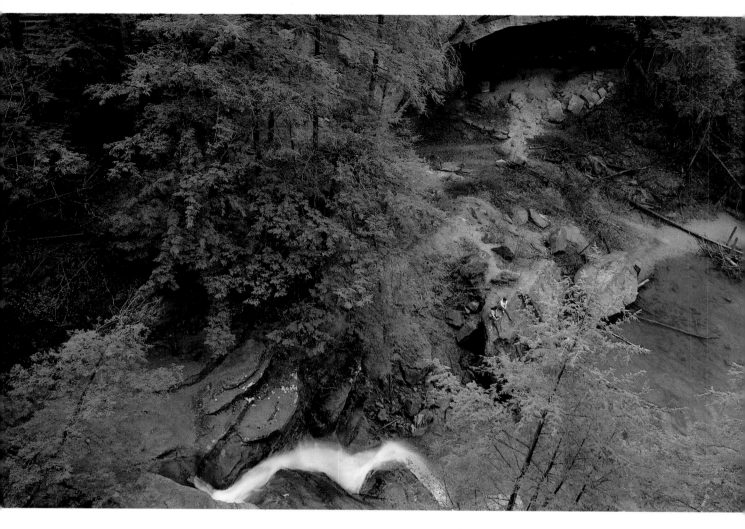

Hikers rest amid waterfalls and sandstone cliffs at Old Man's Cave, Hocking Valley, near Logan, Ohio.

Right, Hayden Run Falls.

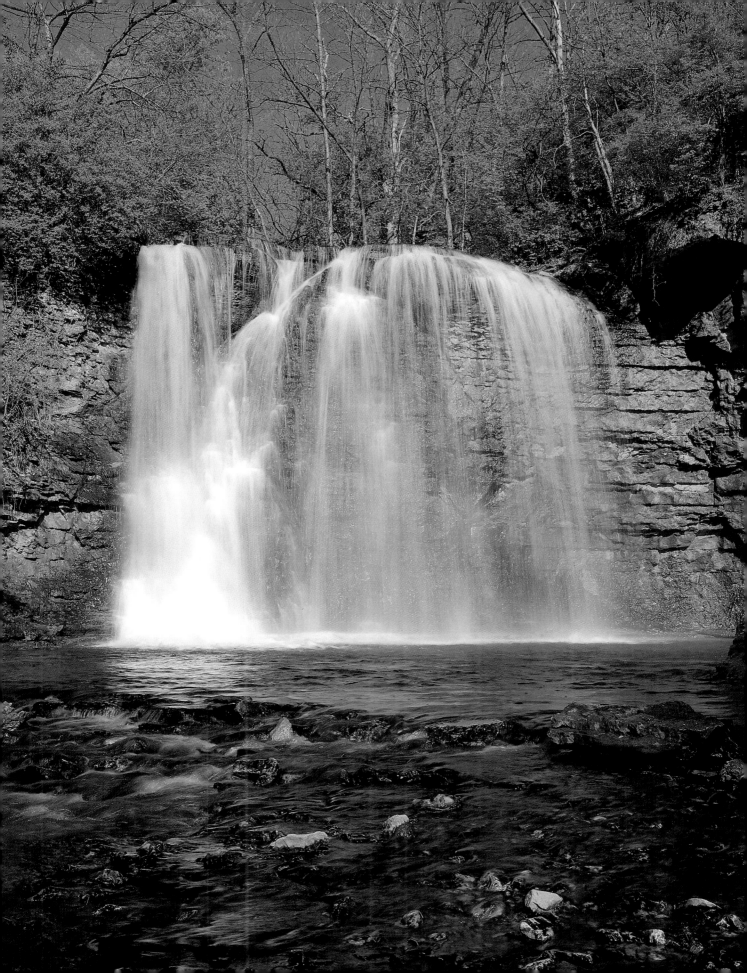

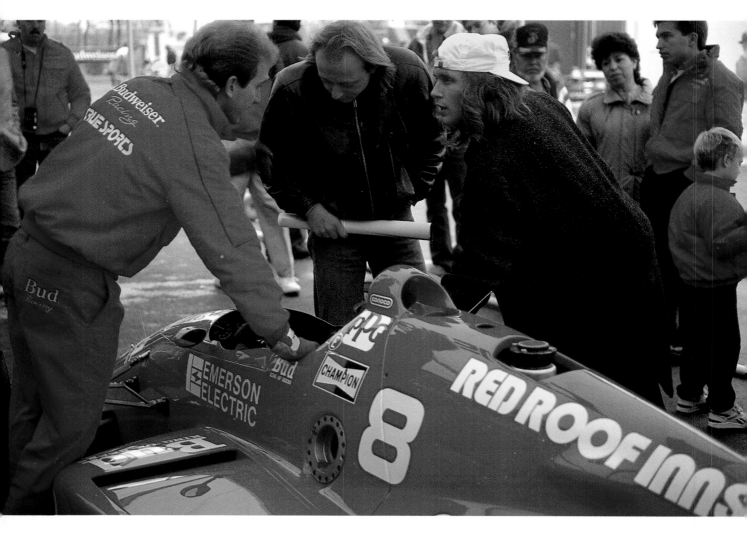

Visitors at True Sports open house.

Golfers putting at Airport golf course, Port Columbus, Ohio.

Following pages, reflections of Columbus skyscrapers.

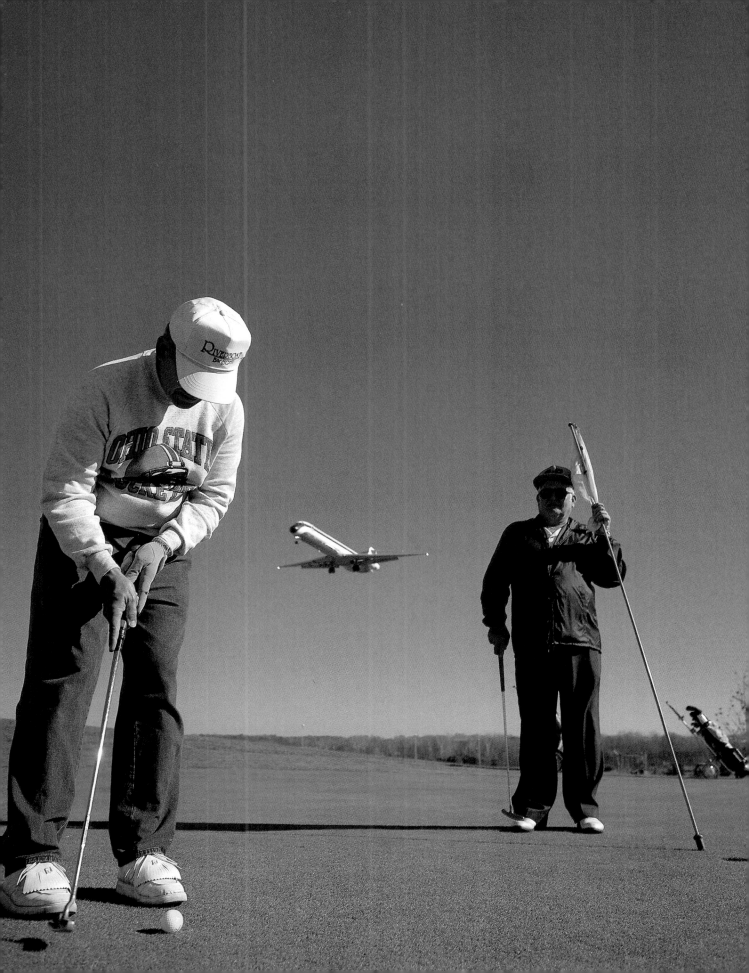

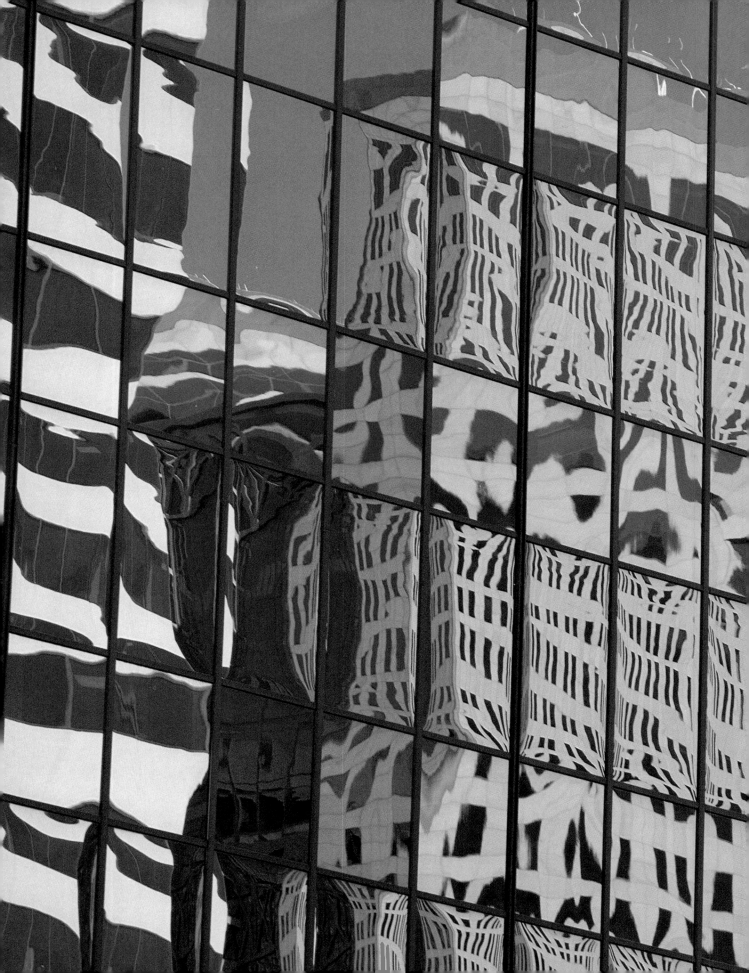

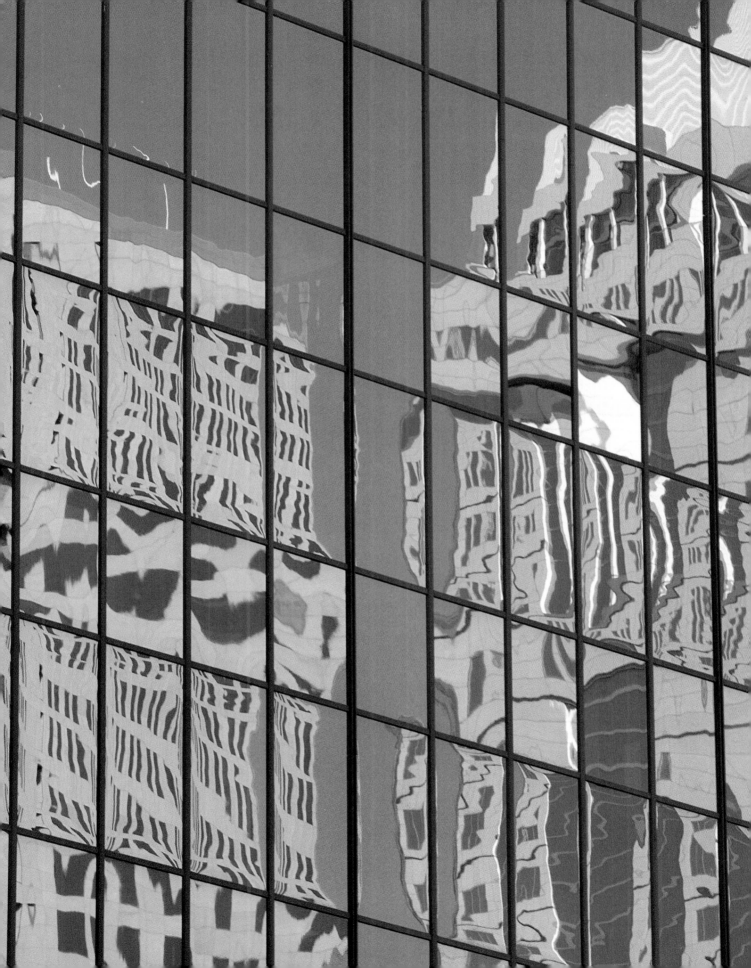

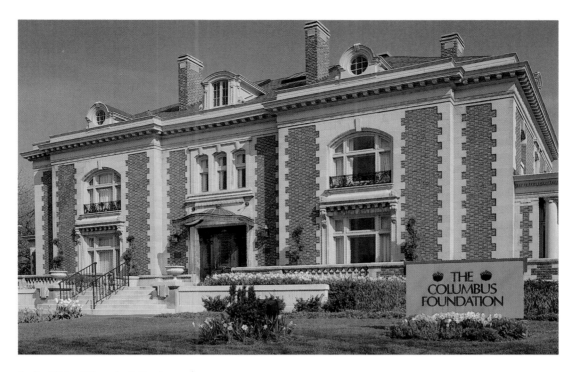

Left, Ohio Historical Society.

The Columbus Foundation (above) occupies the old Governor's Mansion.

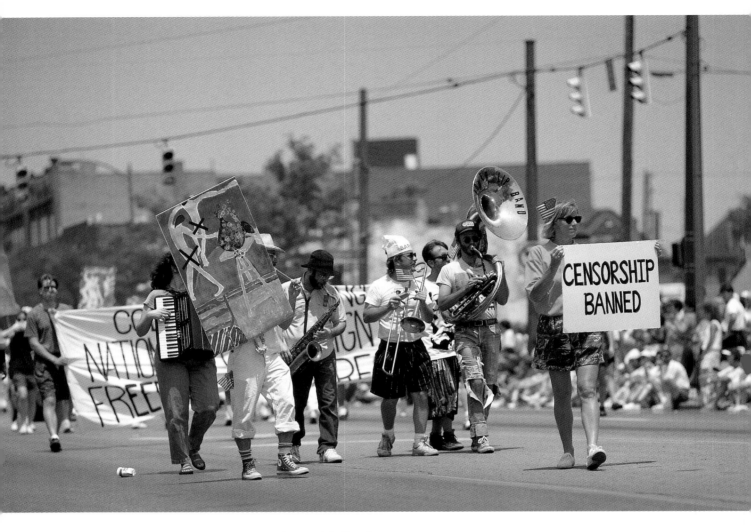

The Short North's annual Doo-dah Parade.

Saxophone player (right) performing at the Greater Columbus Arts Festival.

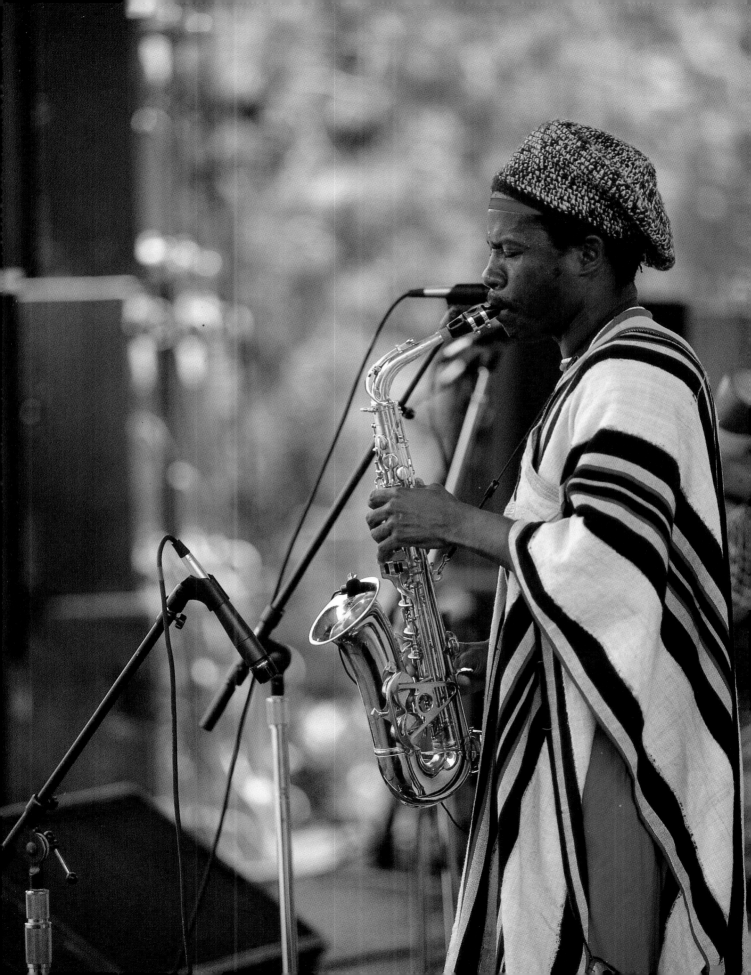

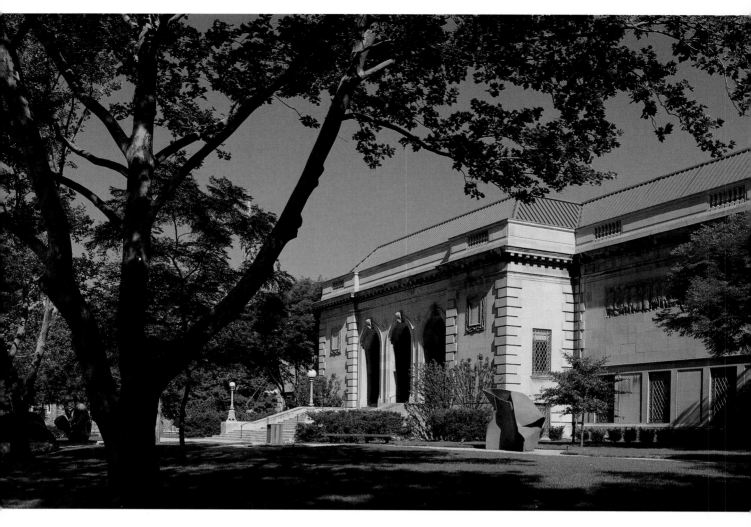

Above, the Columbus Museum of Art.

Neon sculpture at the Columbus Museum of Art.

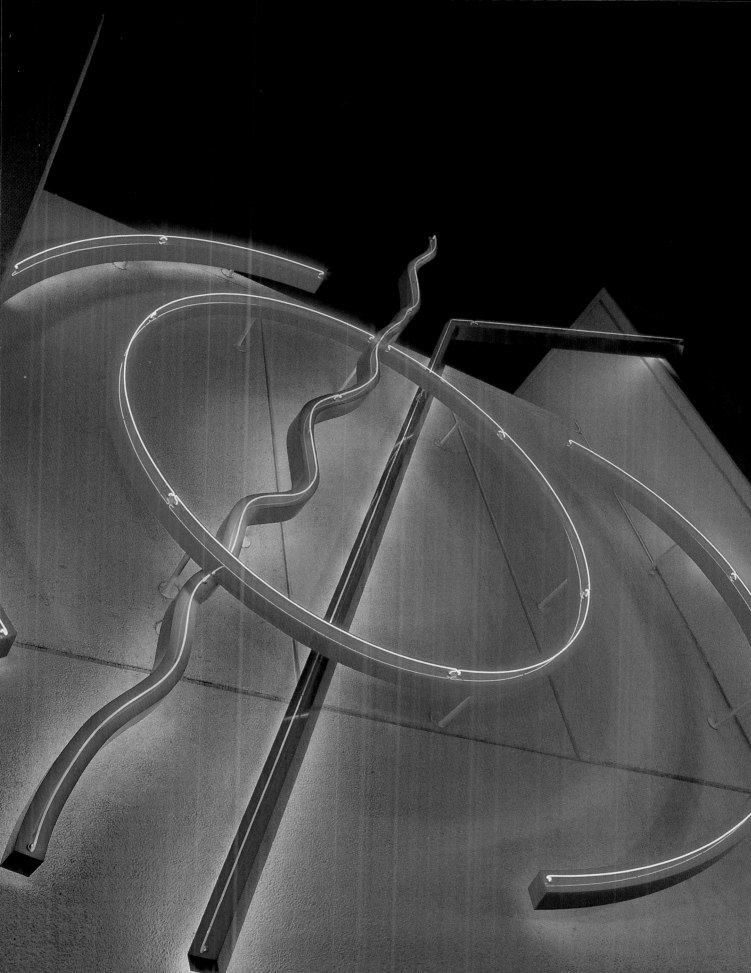

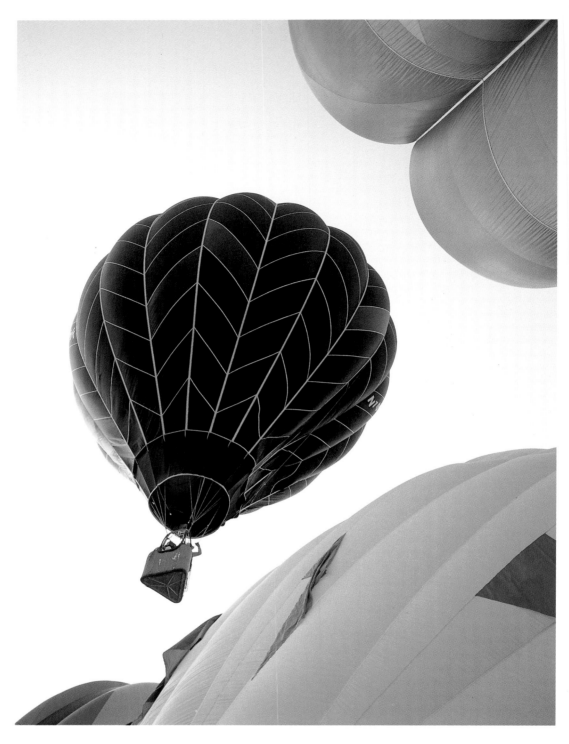

Hot-air balloons at the Franklin County Fair, Hilliard, Ohio.

The Gus Macker 3-on-3 Basketball Tournament (right) is played next to Central High.

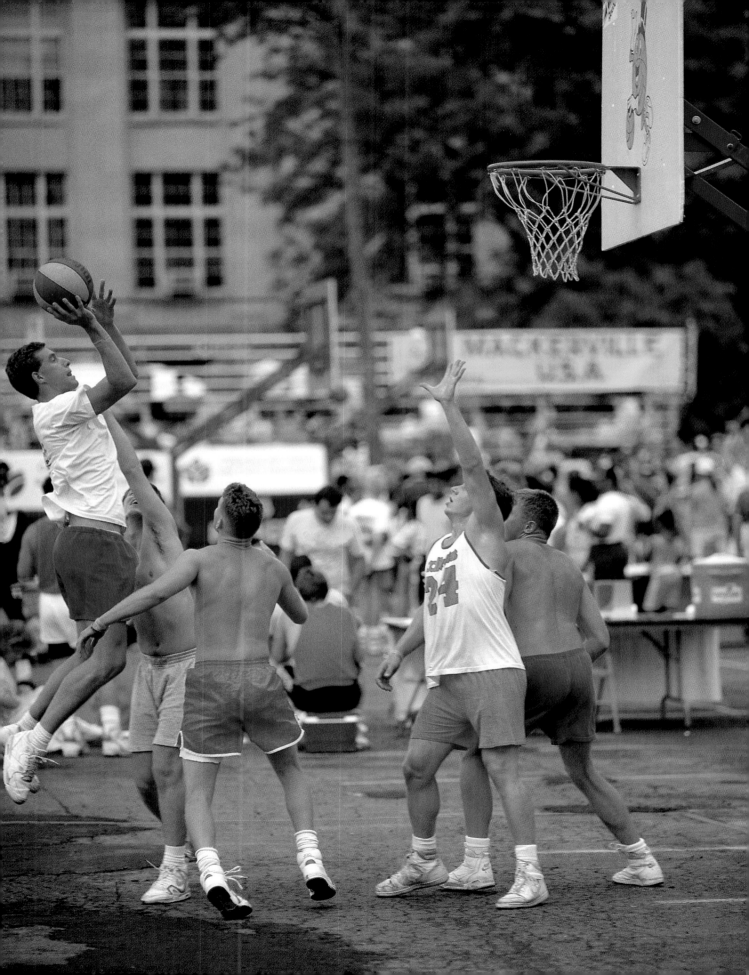

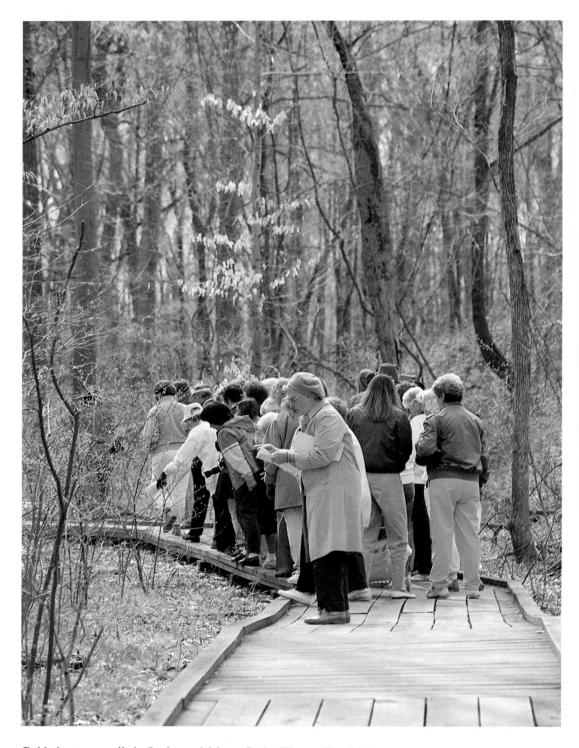

Guided nature walk in Inniswood Metro Park, Westerville, Ohio.

Right, Nationwide Plaza.

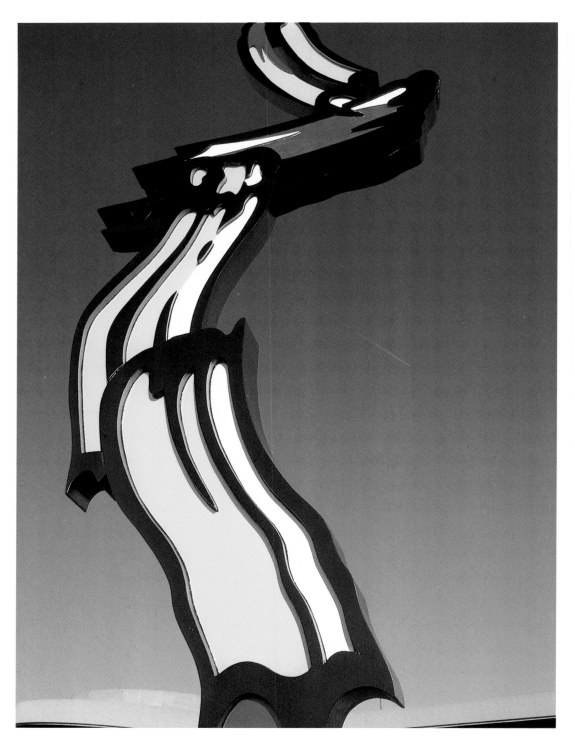

Above, *Brush Strokes in Flight,* Port Columbus Airport.

Right, lightning over the Columbus skyline.

Following pages, contestants in the Homemade Raft Contest, splashing one another at Scioto Superfest.

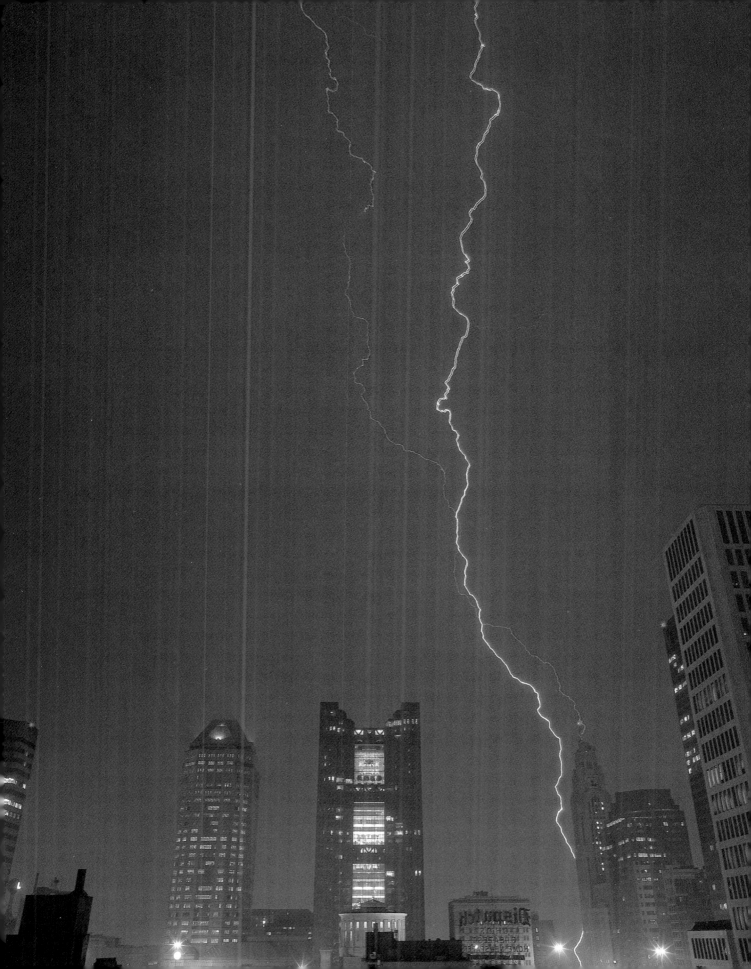

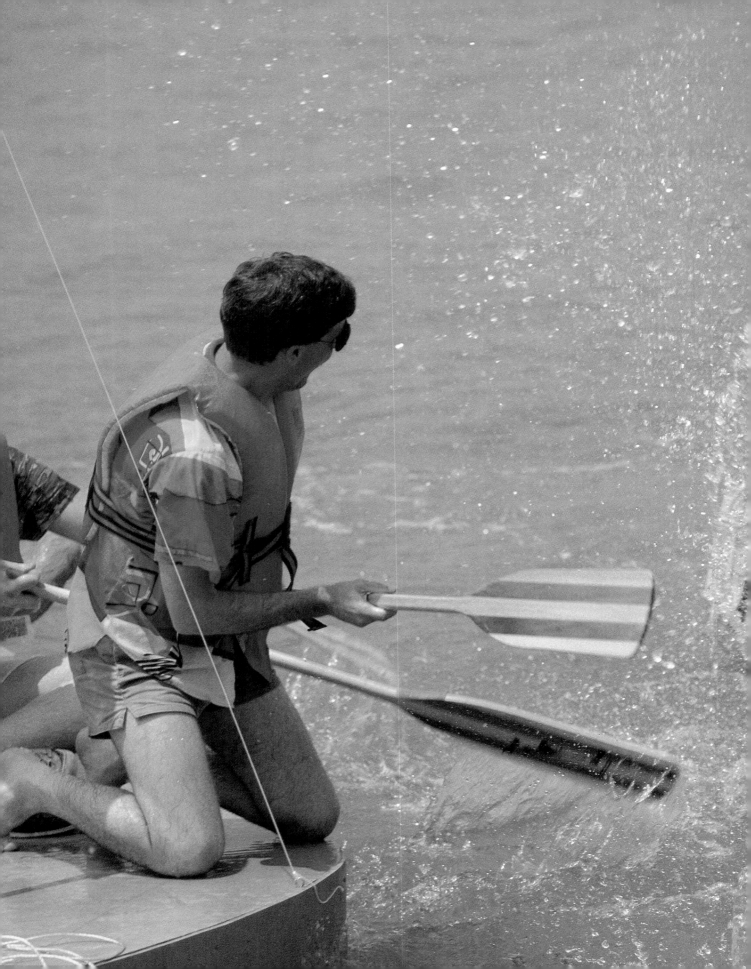

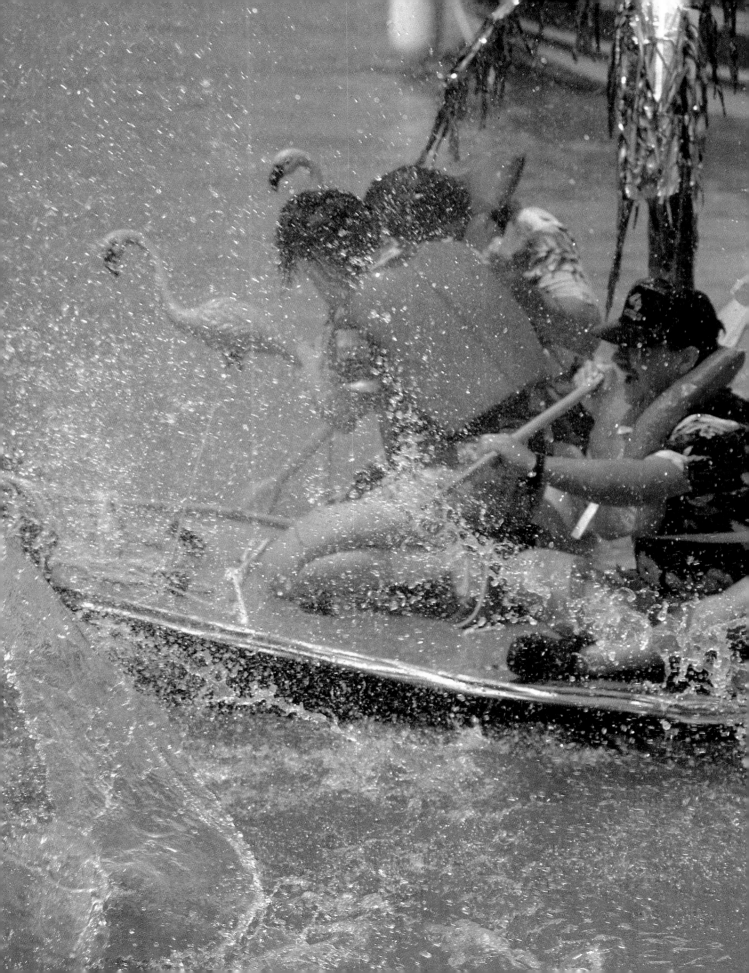

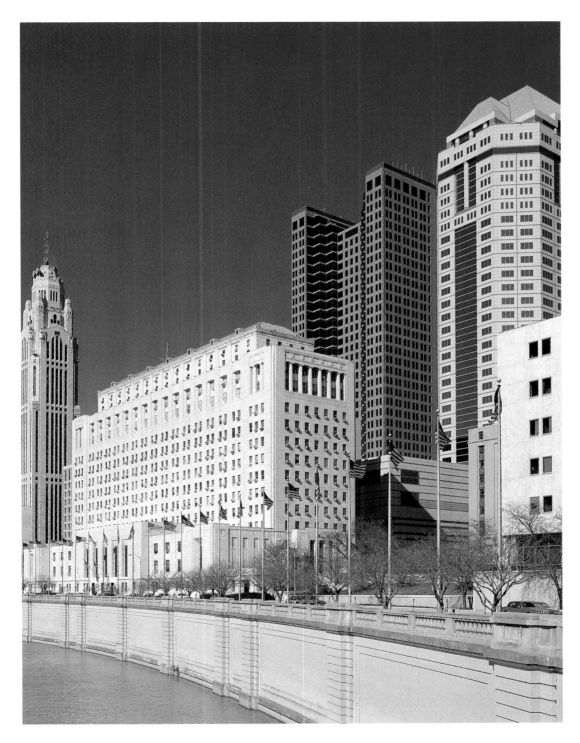

Left, the Junior League of Columbus sponsors the historic Kelton House Victorian Mansion and Gardens.

Flags fly on Civic Center Drive.

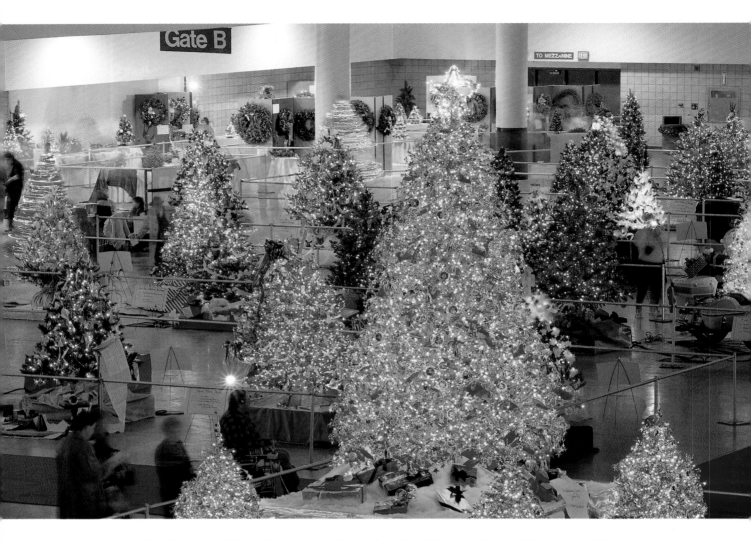

The Festival of Trees is an annual fund-raiser for Children's Hospital held at the Ohio Center.

Right, people outside the Palace Theater.

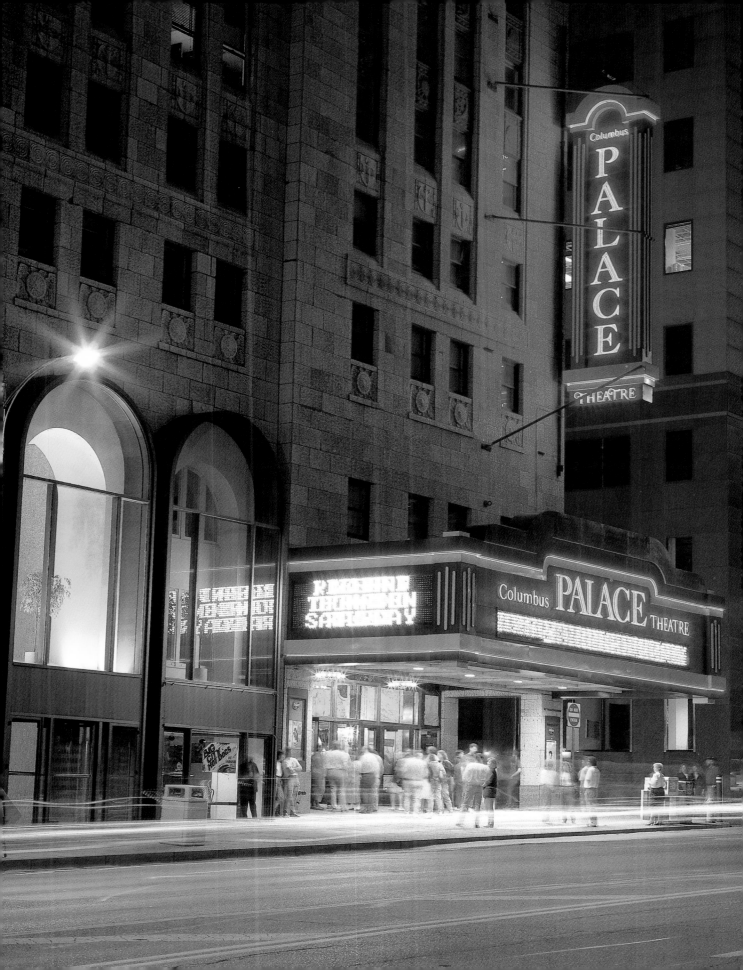

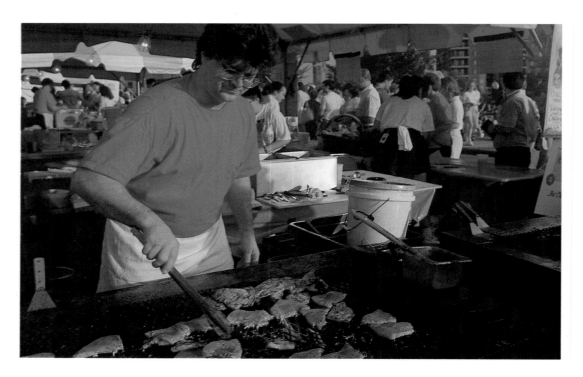

Gourmet food at the Greater Columbus Arts Festival.

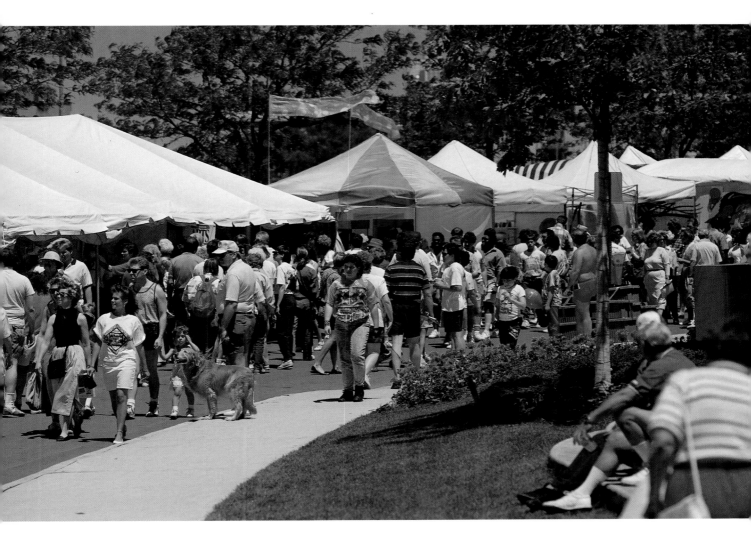

The crowd at the Greater Columbus Arts Festival Street Fair.

Following pages, runners in the Columbus marathon.

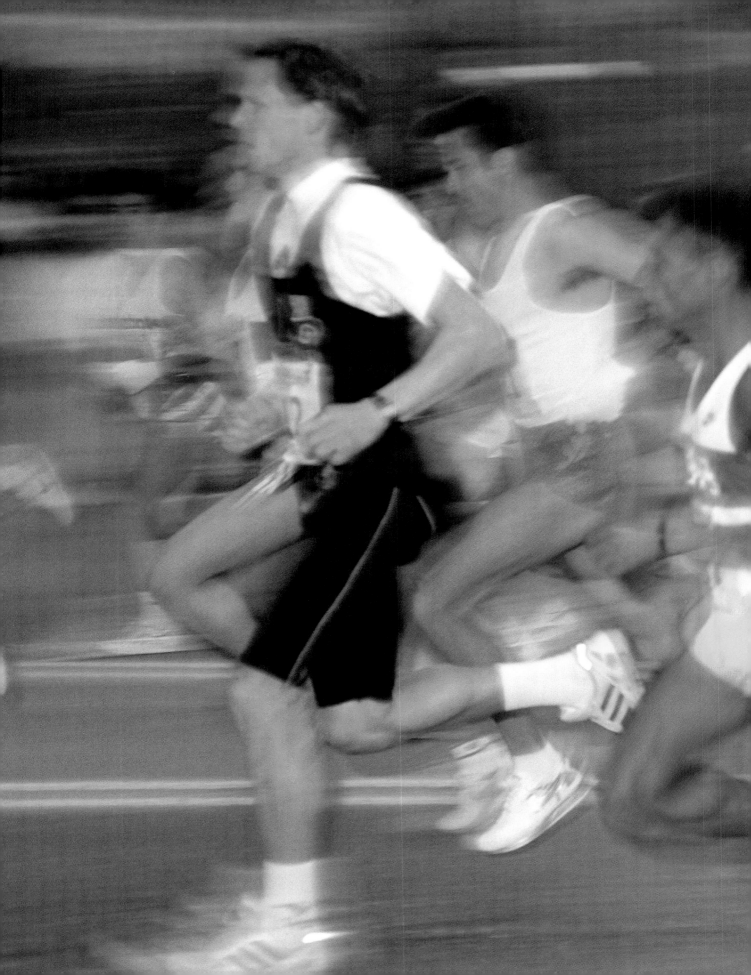

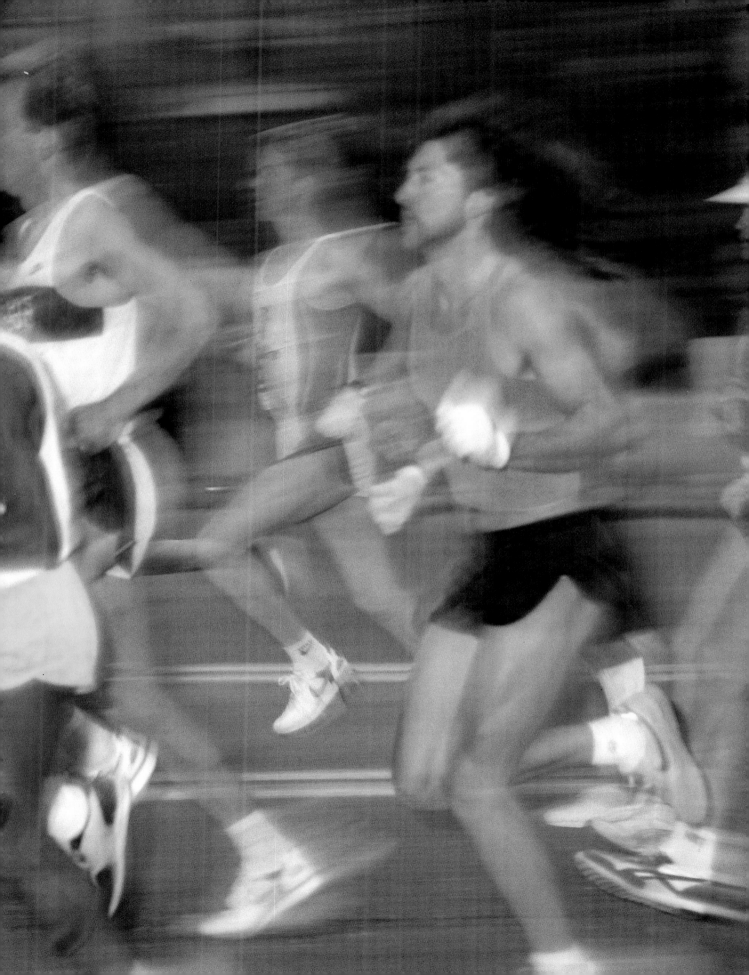

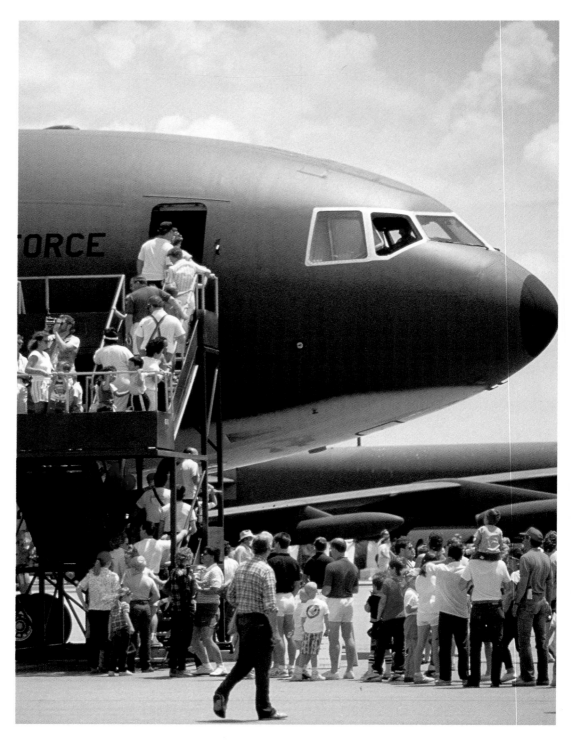

Air show at Rickenbacker Air National Guard Base, a KC-10 tanker.

The flags of all nations (right) fly at Port Columbus International Airport.

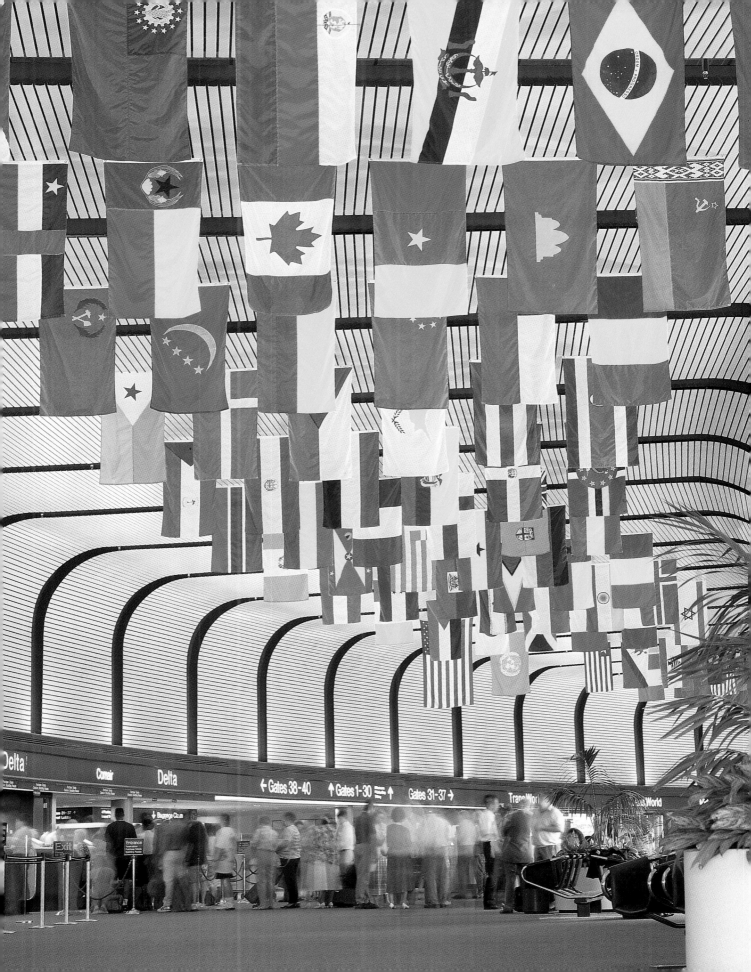

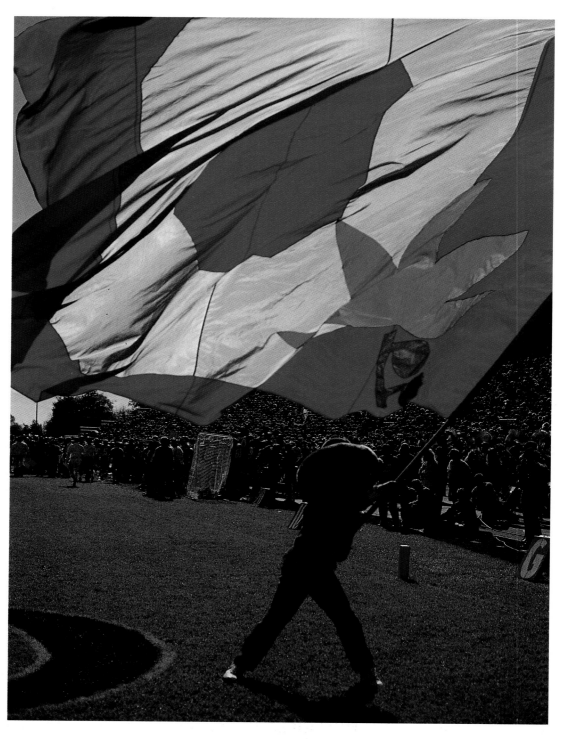

Brutus Buckeye leads a cheer at OSU.

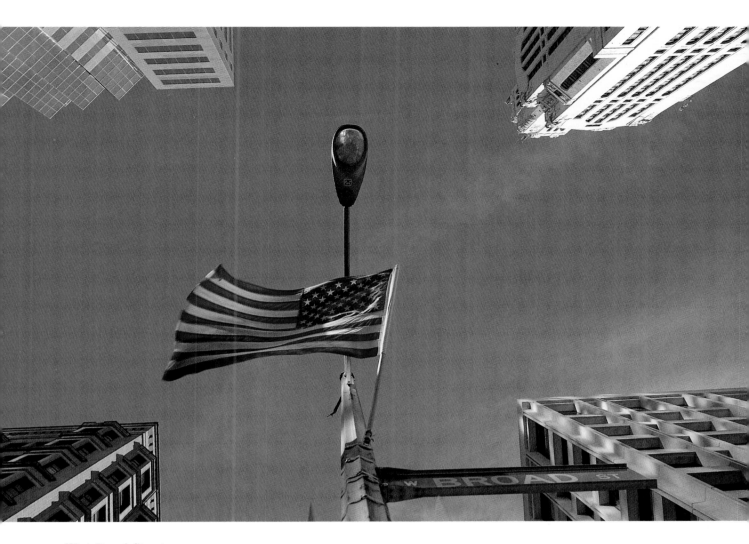

West Broad Street.

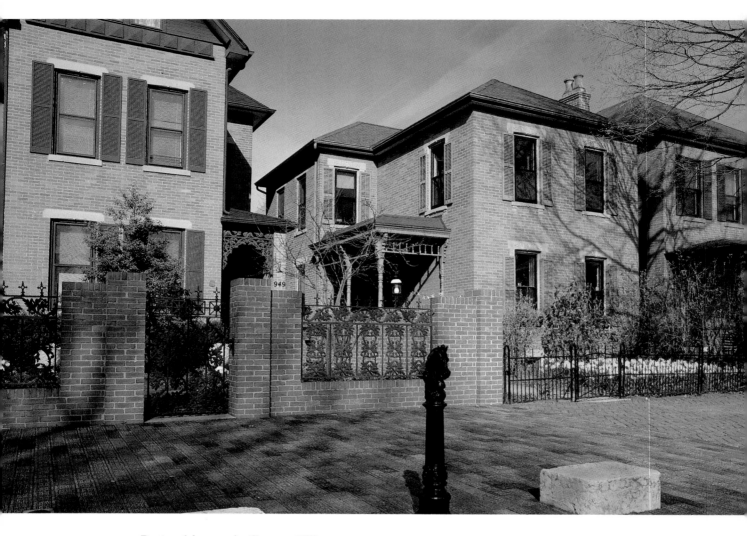

Restored houses in German Village.

Columns of Old Railway Station Archway (right) at Arch Park.

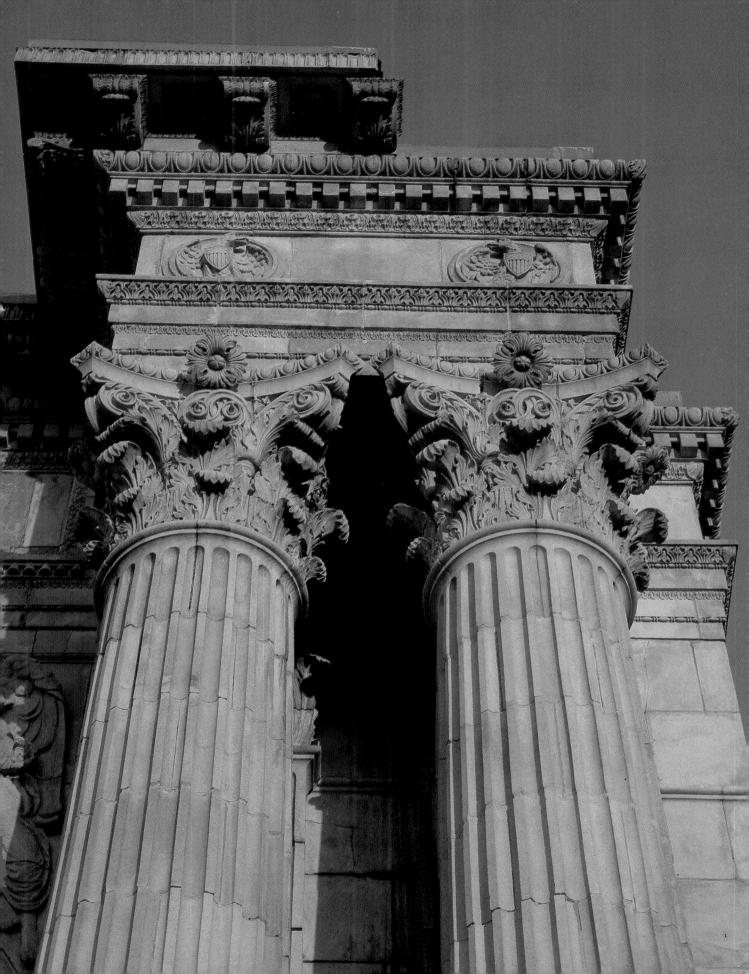

The first residents of Columbus built this burial mound, Campbell Mound.

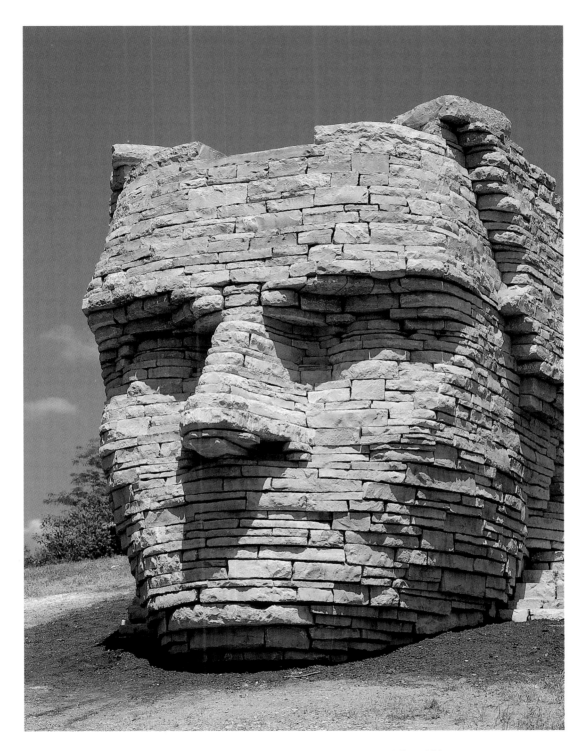

The statue of Chief Leatherlips overlooks the Olentangy River, Dublin, Ohio.

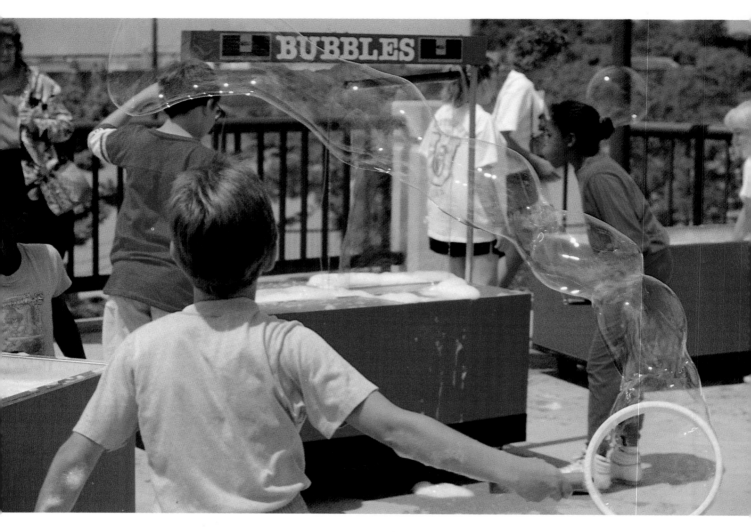

Center of Science and Industry bubble display.

Kids (right) climbing on sculpture in downtown Columbus.

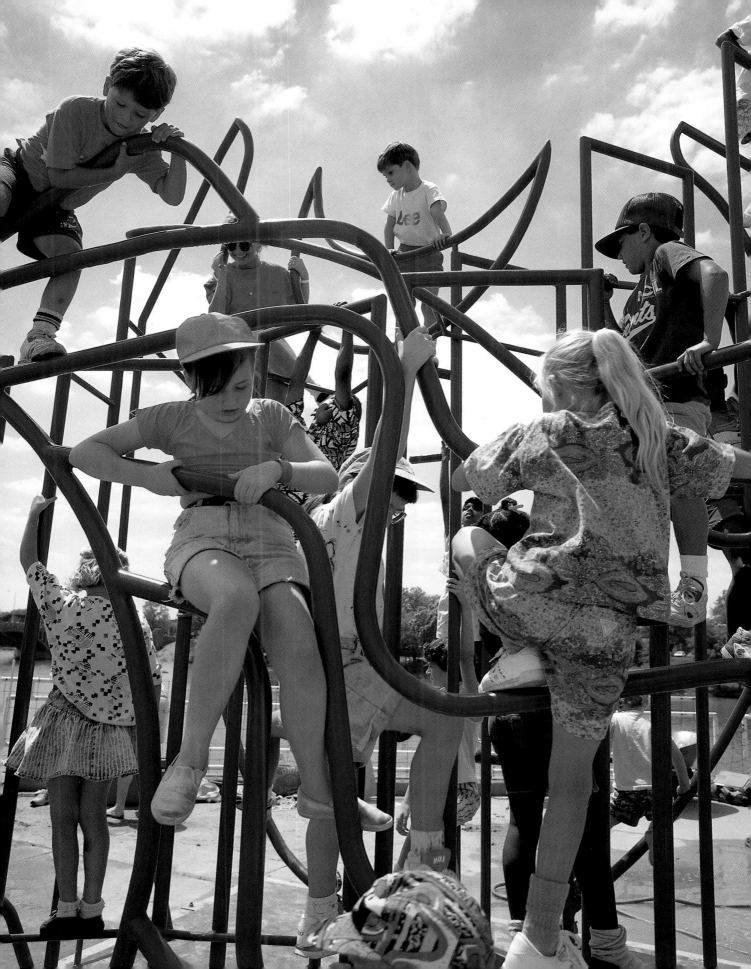

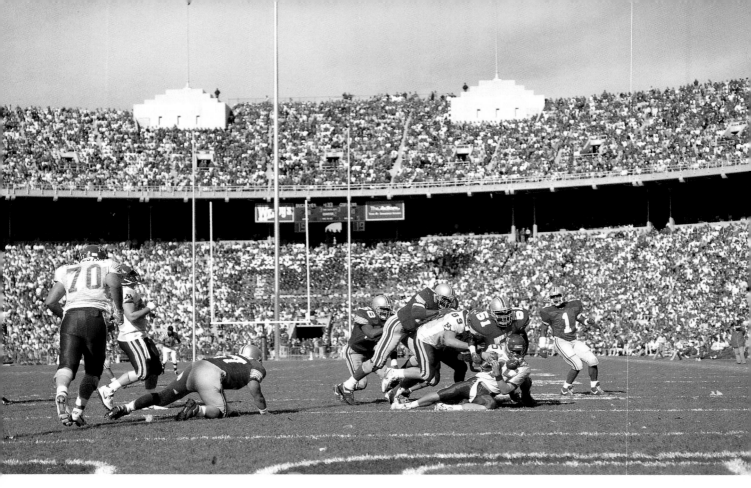

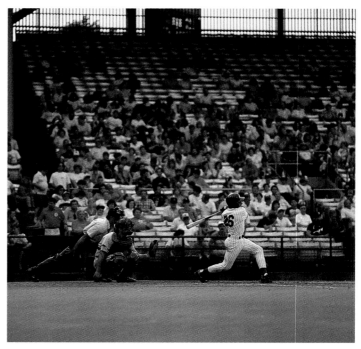

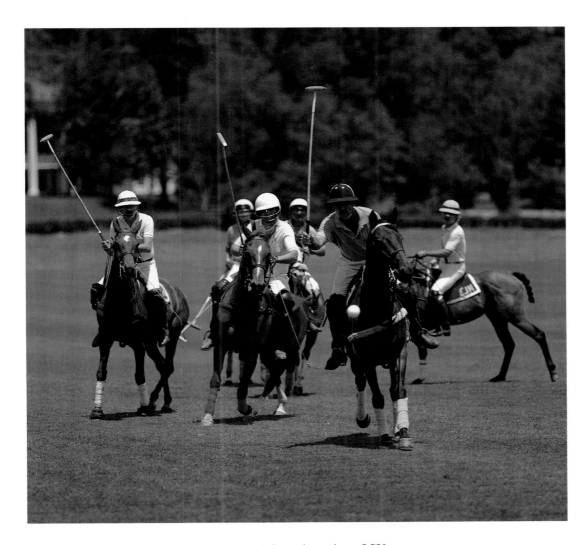

Opposite above, the Ohio State Buckeyes defense in action, OSU.

The Columbus Clippers (opposite below) play at Cooper Stadium. The Clippers are the AAA farm team for the New York Yankees.

The Columbus Polo Club (above) competes with other clubs at the Bryn Du field in Granville.

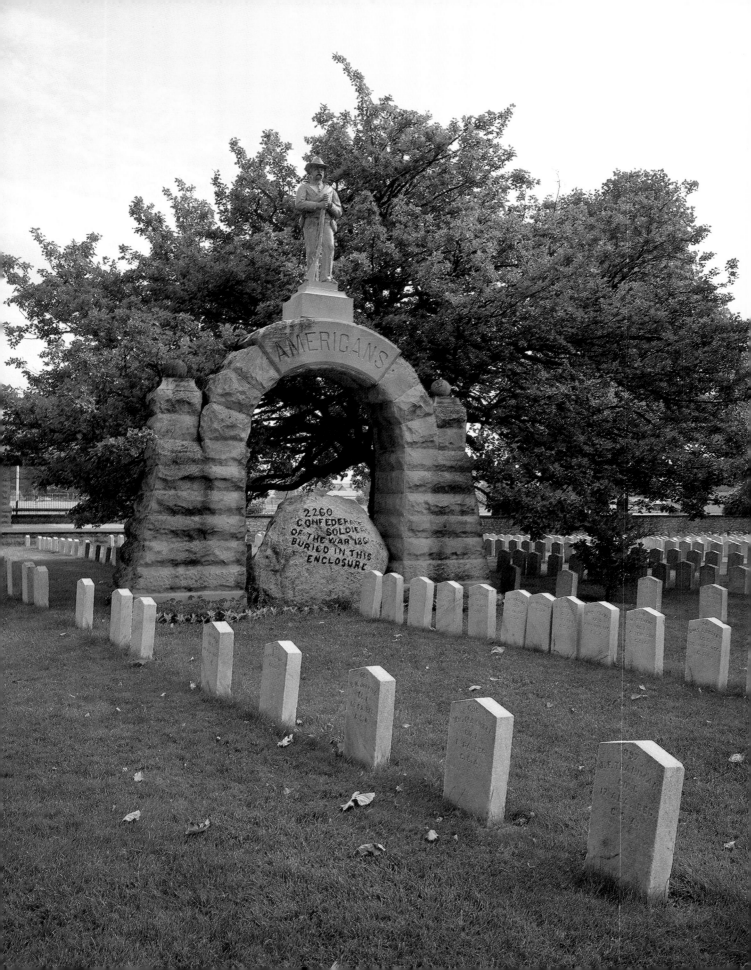

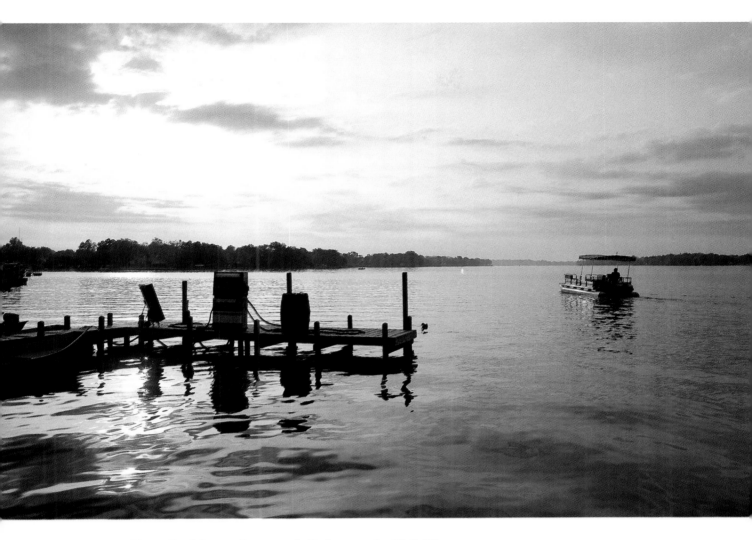

The Camp Chase Confederate Cemetery (left) dates to the Civil War.

Above, early morning on Buckeye Lake, Buckeye Lake, Ohio.

Following pages, a girl splashes down on one of the many rides at the Wyandotte Lake amusement park.

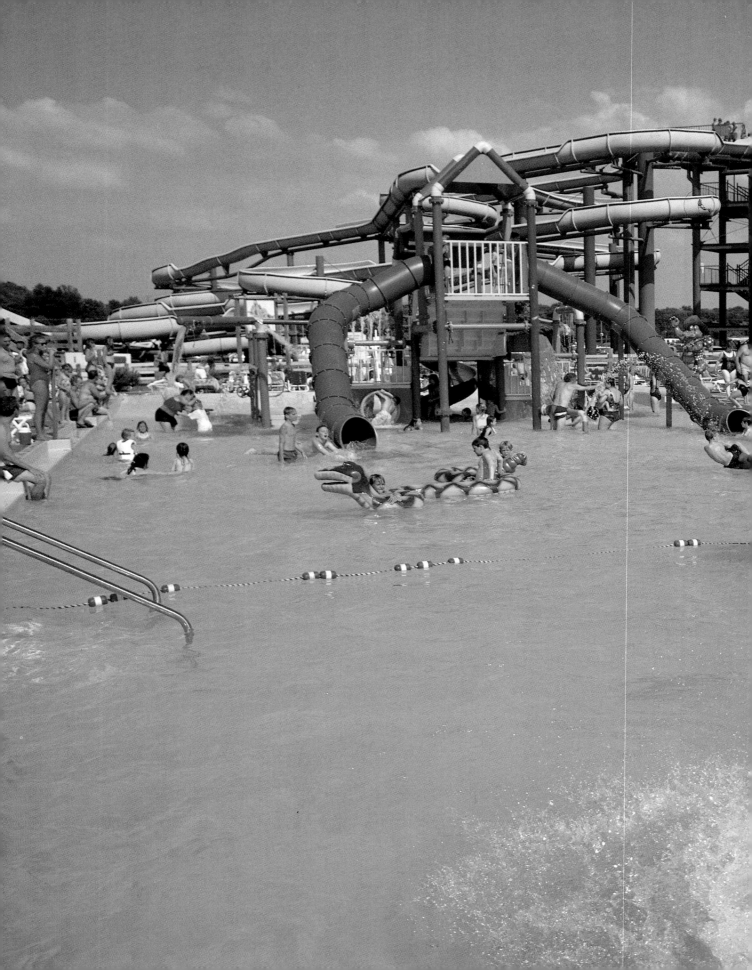

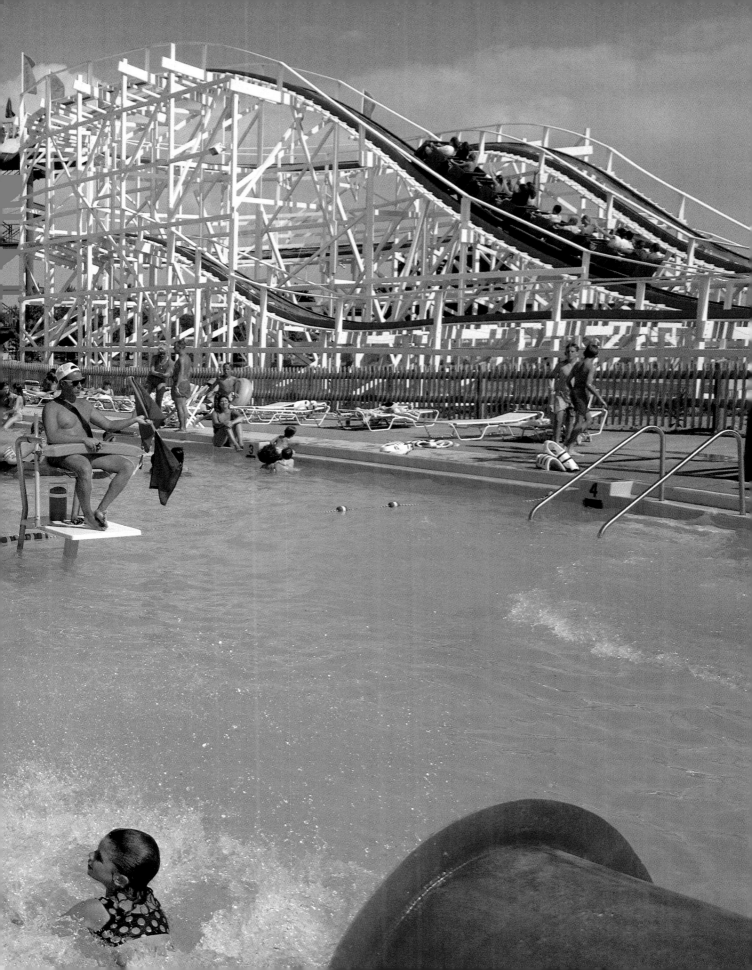

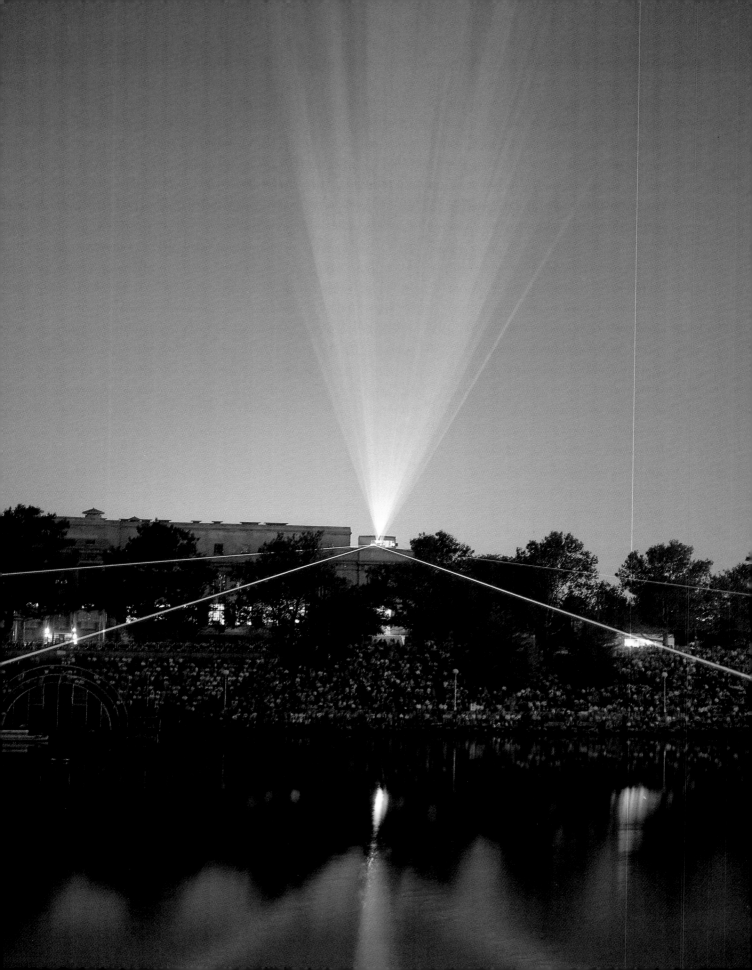

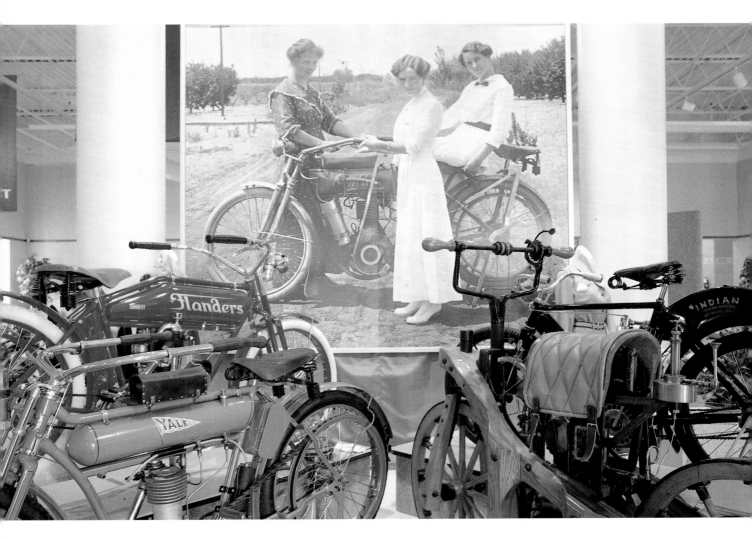

Annual summer laser show (left) on the banks of the Scioto River.

Above, the history of motorcycling is on display at the Motorcycle Heritage Museum.

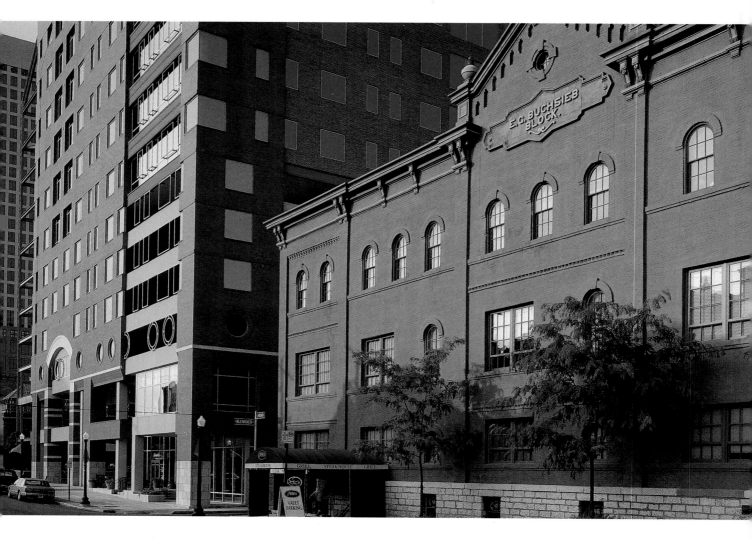

The Brewery district combines postmodern and historic architecture.

Right, the Columbus skyline at twilight.

Following page, "Red, White, and Boom" Fourth of July fireworks on the Scioto River.

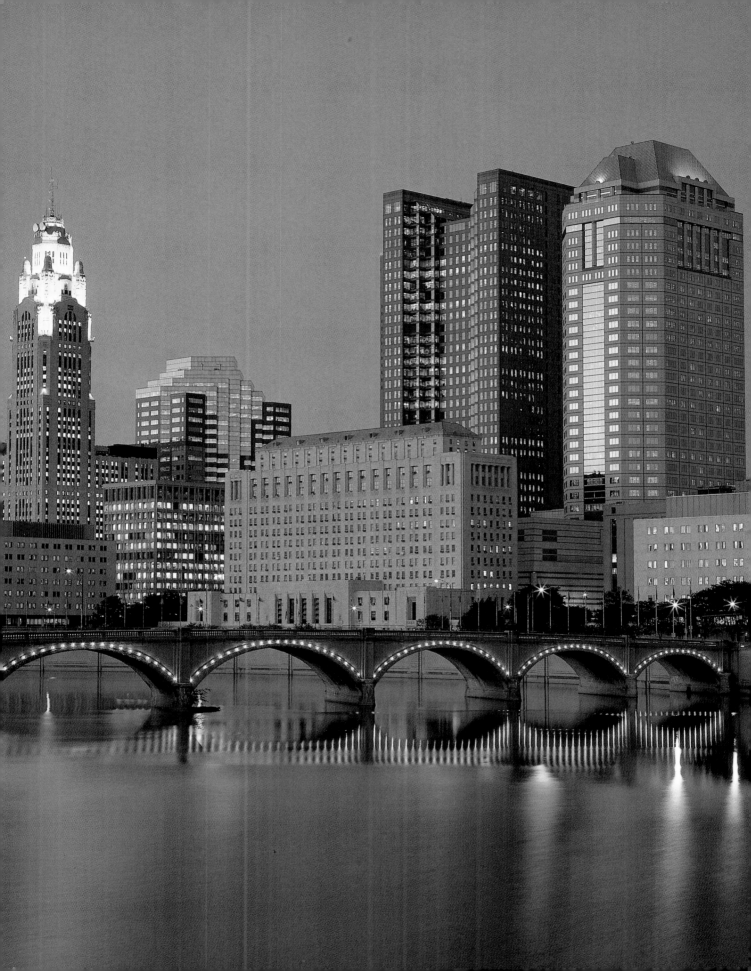

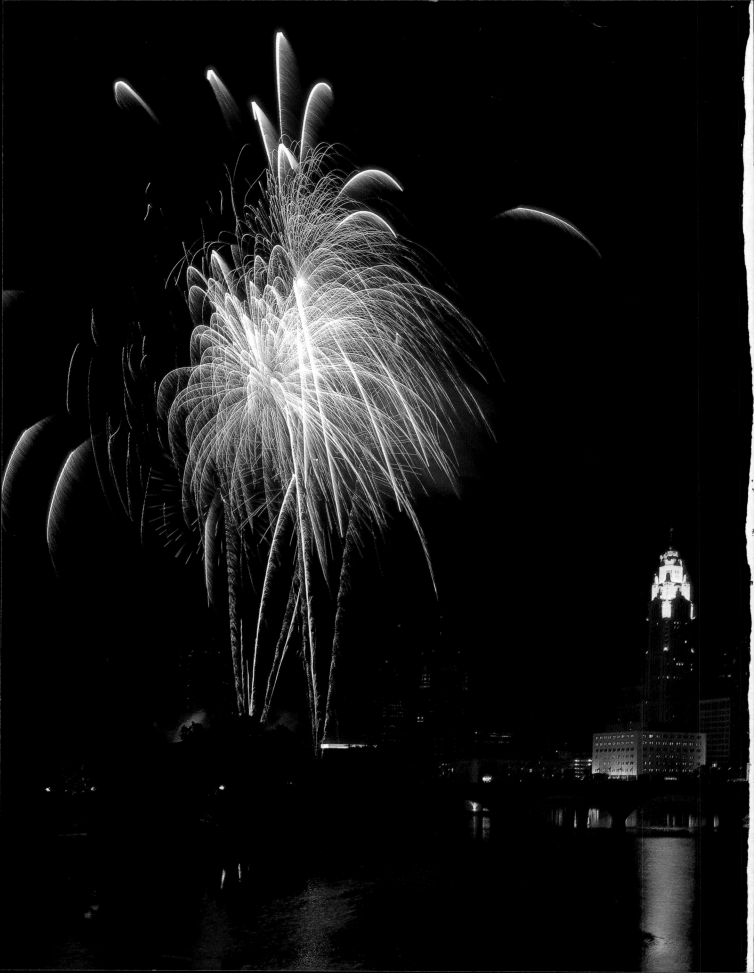